kamera
BOOKS

D0888876

kamerabooks.com

OTHER BOOKS BY COLIN ODELL & MICHELLE LE BLANC

Studio Ghibli
David Lynch
Tim Burton
Horror Films
Jackie Chan
Vampire Films
John Carpenter

Colin Odell & Michelle Le Blanc

ANIME

kamera
BOOKS

First published in 2013 by Kamera Books
an imprint of Oldcastle Books,
PO Box 394, Harpenden, Herts, AL5 1XJ
kamerabooks.com

ISBN
978-1-84243-586-1
978-1-84243-587-8 (epub)
978-1-84243-588-5 (mobi)
978-1-84243-589-2 (pdf)

2 4 6 8 10 9 7 5 3 1

Typeset by Elsa Mathern in Univers 9 pt
Printed and bound by CPI Group (UK) Ltd, Croydon, CR0 4YY

For Hiroki

ACKNOWLEDGEMENTS

As ever we would like to express our thanks to a number of people for their help, support and friendship throughout the writing of this book, this one more than ever: Elizabeth and Paul, Hanako and Gavin and our wonderful godchildren Marika and Hiroki, Alastair, Keith and Hill, Martin and Rosy, John and Elli, Fan and Jessica, Graham and Kirsty, Yoshiko and David. Our love and thanks to Tony, Christine and Marc, and to Truus.

Our sincere thanks to Mr Joshi and all the amazing doctors, nurses, staff and paramedics at UHCW, especially Ward 43, without whom this book would only have one author. And special thanks to Dr Gavin Farrell for getting us through the times in between and beyond.

Many thanks to all those involved with the production of this book: Hannah Patterson, Anne Hudson, Elsa Mathern and Ion Mills. Thanks also to Manga Entertainment for supplying material for review.

CONTENTS

ANIME

Japanese animation, or anime, is an art form that has been gaining popularity across the globe and has altered the way that we view and appreciate animated film. Traditionally, the perception of animation in the West is that it's aimed at children and family markets, through the films of Disney or Pixar and the television cartoons of Hanna-Barbera and Warner Bros' *Looney Tunes*. Although many animations have been created for adults by directors such as Max Fleischer, Ralph Bakshi and Norman McLaren, as well as Eastern European directors such as Jan Svankmajer, Jiri Trnka and Walerian Borowczyk, feature films were not common in the mainstream and animation generally remained in the realm of the experimental or art-house sectors. There is, of course, a large children's market for anime, but what is so exciting about the format is its diversity. Anime's subject matter can range from imaginative fantasies to comedy, drama, horror, sport, science-fiction, romance, avant-garde and erotica and is aimed at audiences that encompass all demographics, from schoolchildren to salarymen.

The term 'anime' is most often used in the West to describe a particular style associated with Japanese cel animation, but in Japan it refers to all animation. Closely associated with anime is manga and, although the terms are sometimes used interchangeably in Western media, they refer to different things. Anime are animated films of Japanese origin. The term comes from the Japanese fondness for condensing words, in this case 'animation'. Manga are

Japanese comic books. Both manga and anime are hugely popular in Japan – the industry is worth billions of dollars – and have been for many decades.

'Manga used to be regarded as something for children until they were around 15,' manga critic Haruyuki Nakano told *Kyodo News* on the fiftieth anniversary of two of Japan's pioneering weekly manga titles. 'But baby boomers in post-war Japan kept reading their favourite manga even after they entered college and became adults. That helped make manga widespread in Japanese culture.'[1]

There is now increasing awareness and appreciation of both anime and manga in Western countries. This book aims to provide an introduction to anime, exploring its origins as an art form as well as introducing key animators and a selection of works for viewing. Names are presented Japanese style, with family name followed by given name. Romanisation of characters is via the modified Hepburn system, with macrons to emphasise double-length vowels, except where the word is in common usage in the English language, e.g. Tokyo instead of Tōkyō.

INTRODUCTION

ORIGINS OF ANIME

Japan has a long tradition of art and literature. During the Heian period (794–1185), e-maki (picture scrolls) became established as an art form. Mainly created during the twelfth century, these beautiful illustrations depicted scenes of court life or historical events. The origins of the Japanese art aesthetic can be seen in these scrolls. During the Edo period (1600–1868) woodblock prints became incredibly fashionable. These were pictures created by artists and transferred onto a woodblock whereupon craftsmen would carve away at the wood to produce a relief of the image, in reverse. This could then be inked and printed to reproduce copies of the original drawing. Multiple blocks could be produced to create multiple colours, sometimes with several inkings to obtain a greater depth of hue, and the finished product could be reproduced quickly and in large quantities. It was a collaborative process that can, in some respects, be likened to the production of anime – whereby the writer, director and key artists determine the creative element of the narrative and design, after which artists and in-betweeners generate the final product. Woodblock prints were easy to reproduce and cheap, which meant that they were very accessible and could be distributed widely. Sometimes a series of popular prints would run to hundreds of thousands of copies. It's similar to the distribution of manga today – multiple copies printed on low-grade paper and

sold cheaply to the public (the price of the woodblock prints could compare roughly with a double helping of soba noodles; manga sells for the equivalent of just a couple of dollars), who are constantly waiting for the next episode in the series. The primary market for these prints generally comprised the lowest ranking of the social hierarchy of the time – merchants and artisans – although the prints were also appreciated by the samurai classes. Known as ukiyo-e, or 'pictures of the floating world', these woodblock prints depicted beautiful landscapes, everyday life from the Edo period, pictures of animals and flowers. Particularly popular were the prints from the pleasure quarters, of geisha and tea-houses, as well as kabuki (classical Japanese drama) actors in famous roles.

The aesthetic style of ukiyo-e is a world apart from Western art of the time. The images are bold and colourful. It is said that the Japanese favour symbolism over realism. One of the most distinctive elements of traditional art is that it is very flat – there is a distinct lack of perspective or shadow and a very different approach to composition with the main focus of the image often off-centre. This design aesthetic can be seen in many anime right up to the present day.

The leading woodblock artists were Katsushika Hokusai (1760–1849), Utagawa Kunisada (1786–1864), Utagawa Hiroshige (1797–1858) and Utagawa Kuniyoshi (1797–1861). (The Utagawa name comes from the famous woodblock print school.) Incredibly prolific, Kuniyoshi produced over 10,000 pictures over the course of his career. He produced a variety of images, but made his name with his series, *One Hundred and Eight Heroes of the Suikoden* (*Tūszoku Suikoden gōketsu hyakuhachinin no hitori*), based on the classic Chinese tale, known in the West as *The Water Margin*. This series of prints featured dynamic designs of the heroes of the story and was enormously popular. The term 'manga' was first used by Hokusai (best known for his print *The Great Wave off Kanagawa*, from the series *Thirty-six Views of Mount Fuji*) to describe his 13 volumes of sketches. The term can be translated as 'whimsical drawings'. Since then, the name stuck and has been used to

describe Japanese comics. Hokusai's manga did not take the form of a comic book as we know it today, but were simply collections of sketches and caricatures, many of which were humorous. Modern manga developed in the years following the Meiji restoration (1868) and notably after the Second World War (when Japan was occupied by the US), reflecting the influence of American culture – particularly comic books and movies – on Japanese society.

Akahon, literally 'red book', named for their vivid red covers, originated in the Edo period and were originally children's books. Produced in a way that was similar to the making of ukiyo-e (the artist would produce the image, then craftsmen would copy that image onto printing plates), akahon were printed on cheap paper and covered a broad range of subject matter. They were hugely popular during and after World War Two because they were an affordable form of media. They also gave emerging artists an opportunity to create and distribute their stories. It was originally through the production of akahon that a young medical student, Tezuka Osamu, got his first break as an artist with *Manga Shōnen* magazine, eventually emerging as the pioneer of this new comic-book form, earning the nickname 'manga no kamisama', the 'God of Manga'. His comics combined dynamic, movie-inspired panels into a thrilling mix of action and adventure. His influence is still apparent today, in his pioneering approach to the way that manga, and later anime, can tell stories.

In the late 1950s the manga market developed into the model we know today. Contemporary manga is distributed usually on a weekly or monthly basis. These are huge, commercially successful publications that can be hundreds of pages long, printed on cheap paper and sold at a low price. Readers can vote on their favourite stories and the most popular become standalone high-quality, multi-episode publications (tankōbon). Their success can also lead to adaptation for the anime format. Popular manga are not only the preserve of the professional artist. Dōjinshi are self-published works by amateurs or those whose work may not initially appeal to mainstream publishers. They usually have high production values

and can be extremely popular – indeed there are many shops in Japan dedicated to selling only dōjinshi. Many professional mangaka (manga artists) started out as dōjinshi artists – notably Takahashi Rumiko, Katō Kazuhiko (aka Monkey Punch), and studio Clamp.

A BRIEF HISTORY OF ANIME

Early forms of animation were developed during the nineteenth century. Although Japan was effectively closed off to the outside world until 1853, when Commodore Matthew Perry appeared with a four-ship squadron in Tokyo Bay and demanded that Japan trade with America, there had been limited trade with China and Holland, and it is thought that the Dutch introduced the magic lantern to the Japanese. Utsushi-e was a slightly different technology, developed from the magic lantern, which was an early type of projector. Images would be painted onto glass slides that could create basic moving pictures using a mechanical slide. Utsushi-e adapted the technique and could back-project images onto Japanese paper, which is partially transparent. Using multiple furo (lanterns), each of which required an operator, quite sophisticated animations could be produced in real time. The Japanese love of bunraku (puppet theatre) and also kabuki offered a wealth of stories from which live animated performances, accompanied by narrators and/or musicians, were created.

The magic lantern was one of the technological innovations that eventually led to the development of the movie camera and projector and the wonderful world of the cinema. The Lumière Brothers' invention first appeared in Japan in 1897 in Ōsaka and, like much of the cinema from the time, mainly comprised short films capturing moving images of everyday life. These included distinctly Japanese scenes of geisha as well as excerpts from kabuki plays. Japan has also had a long history of theatre, and it is the tradition of a noh or kabuki chorus that led the screenings of silent movies to be accompanied, not only by music from a traditional orchestra but also a benshi, or narrator, who would introduce the film and perform many of the roles, providing an expressive commentary on

proceedings. And it truly was a performance. Many benshi became very famous, sometimes being more of a draw than the actors in the films. Early Western films used to have some form of narration but the practice died out about a decade into the twentieth century. However, benshi were a fundamental part of the cinema experience in Japan for many years, even beyond the coming of sound in the cinema. Early anime from the 1920s and 1930s often had benshi narration. The impact of benshi meant that Japanese cinema narrative developed in a slightly different way to other countries' and even early anime were constructed such that they required the input of a benshi to give the film meaning.

Western animations began to appear in Japan around 1909 and, before long, Japanese hobbyists were producing short animations, although not on any great scale. A scrap of film, just three seconds long, depicting a boy drawing the characters for 'moving pictures' on a chalkboard, is thought to be one of the earliest surviving animations but is impossible to date accurately. Most early anime has not survived and there is some confusion as to the earliest anime but the first professional animation is widely considered, if only because it was the first to be screened theatrically, to be *The Story of Concierge Mukuzō Imokawa* (*Imokawa Mukuzō Genkanban no Maki* [1917]) by Shimokawa Ōten, thought to have been created using images drawn on a chalkboard. Kōchi Junichi made *Sword of Hanawa Hekonai* (*Hanawa Hekonai, Meito no Maki* [1917]). This was swiftly followed by Kitayama Seitarō's *Monkey and the Crab* (1917) and *Momotarō* (1918), the latter derived from a traditional Japanese folktale about a boy found by an elderly couple inside a giant peach.

These pioneers, particularly Kitayama and Kōchi, forged a path for other animators. Kitayama established the first animation studio, Kitayama Eiga Seisakujo, in 1921, where such animators as Murata Yasuji, Ōfuji Noboro and Yamamoto Sanae would develop their skills. Yamamoto made such films as *Usagi to Kame* (1924), a version of *The Tortoise and the Hare*, and *The Mountain Where Old Women Are Abandoned* (*Obasuteyama* [1924]). These films are amongst the earliest that still exist.

Although the customary method for producing anime employs cel animation – that is, drawing individual images onto acetate cels, creating between 8 and 24 images per second of film (depending on the quality of the production) to achieve the illusion of motion – cels (originally cellulose nitrate, an early form of acetate) were not used in Japan until 1929 and took many years to become the standard medium for Japanese animation. Sadly, many early animations, and indeed films, have been lost. Some were destroyed in the Great Kantō Earthquake of 1923, others in the fire bombings of Tokyo during the Second World War.

Murata Yasuji was one of the early pioneers of anime. His style and techniques are surprisingly modern. In *Tarō's Toy Train* (*Tarō-san no Kisha* [1929]) a young boy dreams about a group of badly behaved animals that are riding his new train set. *The Bat* (*Kōmori*, [1930]) almost has an air of Chuck Jones or Max Fleischer to it, as creatures are cut in half and rejoined in this tale of a bat who, being neither a bird nor a beast, sides with both factions as they battle each other. Ōfuji Noburo made a number of chiyogami eiga, silhouette animations using paper cut-outs, inspired by the work of Lotte Reiniger and heavily influenced by shadow puppet tradition. Many of his early films were quite abstract and generally accompanied a musical score. *The Whale* (*Kujira* [1927]) was one of the first sound films. Ōfuji's next film, *Black Cat* (*Kuro Nyago* [1931]), had synchronised sound and featured the charming eponymous feline, dancing at the behest of four children and later joined by a dancing tabby. The first genuine talking picture was Masaoka Kenzō's *Within the World of Power and Women* (*Chikara to Onna no Yo no Naka*), made in 1932 and released the following year.

The 1930s and 1940s were a turbulent time for Japan, with the invasion of Manchuria followed by World War Two, and many of the anime produced during these decades depicted heroes striving to accomplish tasks with honour and virtue as the government took an increasing interest in controlling the media. Murata Yasuji made a number of films around this time, including *Masamune and the Monkeys* (*Saru Masamune* [1930]), as well as *Aerial Momotarō* (*Sora*

no Momotarō [1931]) and *Momotarō's Underwater Adventure* (*Umi no Momotarō* [1932]). Kato Teizo's *Plane Cabby's Lucky Day* (*Oatari Sora no Entaku* [1932]) features a helpful pilot who is rewarded for his endeavours and concludes with the line, 'Charity is a good investment.' As Japan entered the war, the government increasingly used anime as a form of propaganda. *Sankichi the Monkey: The Air Combat* (*Osaru no Sankichi: Bokusen* [1942]) featured playful monkeys engaging in an aeroplane dogfight when invaders arrive. 'Protect our skies!' they cry with zeal. *Momotarō's Sea Eagles* (*Momotarō no Umiwashi* [1943]), directed by Seo Mitsuyo, a protégé of Masaoka, was made with the assistance of the Japanese Navy and featured the ubiquitous peach boy. It told a tale of Momotarō and his animal chums fighting together. The heroes attack the large, stupid demons (representing British and American forces) on an island in a sequence clearly representing the attack on Pearl Harbour. Its sequel was Japan's very first animated feature-length film – *Momotarō's Divine Sea Warriors* (*Momotarō: Umi no Shinpei* [1945]). It featured Momotarō and his regular group of buddies fighting to liberate an Asia that has been stolen from them by the Allies.

The period immediately after the war and the subsequent American occupation was a difficult time for poverty-stricken Japan. Following their defeat, the Japanese began to reflect on who they really were and a new style of melodrama, pioneered by such great directors as Ozu Yasujirō and Naruse Mikio, developed in the cinema. Few animations were produced during this time, although some of the early animators were still practising their craft. Ōfuji's animation, *The Whale* (*Kujira* [1952]), a remake of his 1927 short, was exhibited at Cannes, winning second prize, and *Ghost Ship* (*Yūreisen* [1956]) won the first prize at the Venice Film Festival that year.

It was the Tōei Dōga studio, owned by one of Japan's most famous production studios, Tōei Co, that was pioneering the development of anime as we know it. The company acquired Nippon Dōga (Japan Animated Films Company), the animation studio established by Yamamoto Sanae and Masaoka Kenzō in the late 1940s. Mori Yasuji and Yabushita Taiji directed Tōei's first notable short cartoon, *Little*

Kitty's Graffiti (*Koneko no Rakugaki*), in May 1957. The studio then set about creating feature films. Recognising the success of Disney animations, Tōei produced Japan's first colour animated feature film, *Hakujaden* (*The Panda and the Magic Serpent*), in October 1958, an attempt to compete with American animations, albeit for a local market. Yamamoto, who had learned his craft at Kitayama Eiga Seisakujo in the 1920s, was fundamental to the development of these early post-war animations. As well as *Hakujaden* he worked on such productions as *Journey to the West* (*Saiyu-ki* [1960]), aka *Alakazam The Great* and *Arabian Night: Sinbad's Adventure* (1962), for Tōei.

By 1962 over ten million TV sets had been sold to Japanese consumers and Tōei also developed animated series for television, recognising that medium's insatiable need for content. The studio adapted popular manga such as *Tetsujin 28-gō* (1963–66), featuring a ten-year-old boy who controls a giant robot to fight crime, and *Cyborg 009* (1968). For the girls there was naughty schoolgirl, *Akane-chan* (1968), as well as *Sally the Witch* (*Mahōtsukai Sarī* [1966–68]), based on Yokoyama Mitsuteru's manga and widely considered to be the first shōjo (girls') anime. From the magical girl sub-genre, it tells the tale of Sally, a princess from the world of witches, who visits earth and, naturally, mild magical mayhem ensues. Tōei remains amongst the most prolific of the animation studios, generating a bewildering number of hours of anime at a relentless pace. Many of Japan's most respected animators gained experience on the factory floor at Tōei, including Rintarō and Matsumoto Leiji as well as Takahata Isao and Miyazaki Hayao.

Meanwhile, the god of manga, Tezuka Osamu, had established his own company, Mushi Productions, and developed a TV adaptation of his 1952 manga *Astro Boy* (*Tetsuwan Atomu* [1963]), his most famous character, and this became a phenomenal success. He followed this with *Jungle Emperor* (*Jungle Taitei* [1965– 66]), aka *Kimba the White Lion*, again based on his 1950s manga, which was the first colour TV anime. Tezuka recognised the potential for anime to appeal to a broad audience demographic

early on and created a number of anime aimed at adults, including *Arabian Nights* (*Senya Ichiya Monogatari* [1969]), aka *One Thousand and One Nights*, which included the erotic elements from the source material, as well as *Cleopatra* (1970), which was given the somewhat dubious title *Cleopatra, Queen of Sex* in the USA, and *Kanashimi no Belladonna* (1973). Unfortunately, Mushi Productions suffered financial difficulties in the early 1970s but a number of key members formed new production companies such as Sunrise Studios and Madhouse, which would go on to produce some of the most popular and acclaimed anime of all time.

Many TV anime in the 1960s were based on Western literary classics. In 1969 the prestigious World Masterpiece Theater (originally created by Mushi Productions, which was later succeeded by Nippon Animation) began to broadcast quality anime. The first was Tezuka's supernatural revenge drama *Dororo* (*Dororo to Hyakimaru* [1969]) and this was followed by *Moomin* and many Hans Christian Anderson tales. Other anime based on Western stories included *Heidi, The Girl of the Alps* (*Arupusu no Shōjo Haiji* [1974]), *A Dog of Flanders* (*Furandāsu no Inu* [1975]), *Swiss Family Robinson* (*Kazoku Robinson Hyōryūki* [1981]) and *Anne of Green Gables* (*Akage no An* [1979]). *Lupin III*, based on a manga by Monkey Punch, which was inspired by Maurice Leblanc's gentleman thief Arsène Lupin, was a TV show that ran for several seasons (starting in the early 1970s). The character later inspired a number of feature films.

Anime really began to establish itself in the 1970s. Works based on the prominent, eclectic and occasionally controversial mangaka Nagai Gō began to hit television screens. These included such diverse series as *Devilman* (1972–73) and *Cutie Honey* (1973–74), but one of the most influential was *Mazinger Z* (1972–74). Himself influenced by *Astro Boy*, Nagai's tale of a super robot constructed from Super-Alloy Z (developed from the element Japanium, which is, of course, found only inside Mount Fuji) whose purpose was to fight evil machine beasts created by Dr Hell, contributed to the flood of *mecha* (suited-robot, machine-based) anime that flourished throughout the 1970s and 1980s. These included Tomino Yoshiyuki's

Mobile Suit Gundam (1979–80), which has continued, in a variety of updated incarnations, to this day, and *Super Dimension Fortress Macross* (1982–83), an adventure drama set against the background of intergalactic war, with spectacular battles and giant robots. *Space Battleship Yamato* (1974–75) was hugely influential. It was a space opera, a grand-scale epic tale. Director and designer Matsumoto Leiji established a distinctive style for the series, a well-constructed plot and strong characterisation. Enormously popular, in many respects it was a catalyst for the rise of otaku (obsessive fan) culture. A huge fan following built up around these science-fiction series and magazines such as *Animage*, established in 1978 by Tokuma Shoten Publishing, recognised this. As well as publishing serialised manga, it also allowed fans to discuss and vote on their favourite anime and characters. *Newtype* magazine, published by Kadokawa Shoten, followed in 1985. These quality magazines also placed an emphasis on the anime creation process, highlighting the artistic elements of the medium and running articles about anime/manga creators.

A mangaka working in the 1980s was Takahashi Rumiko. Originally a dōjinshi artist, her delightfully eccentric *Urusei Yatsura* (1981) was adapted for television by Oshii Mamoru and became a huge success. Other anime based on her manga, such as *Maison Ikkoku* (1986–8), the mildly bonkers but utterly captivating *Ranma ½* (1989–92), and *Inuyasha* (2000–04) consolidated her position as the bestselling female mangaka in the world and her influence on anime is still apparent, even today.

The 1980s saw a number of significant developments for the format. By this time anime had expanded not just within television and cinema but also to the new and thriving video and laserdisc markets. The later formats, called OVA (Original Video Animations), were effectively direct-to-video productions (this is common in Japanese live-action cinema as well). OVA allowed more specialised material to be produced and distributed cheaply as well as providing springboards for new projects or to release further versions of existing anime that had passed their peak popularity but retained enough fans to ensure commercial viability. Oshii's *Dallos* (1983)

was considered to be the first OVA but it wasn't successful. Ishiguro Noboru's post-apocalyptic *Megazone 23* (1985) was more popular. Biker Shogo believes that he lives in 1980s Tokyo but this is an illusion and he is actually living on a giant spaceship in the twenty-fourth century. The series would eventually run to four parts.

OVAs were relatively cheap to produce and allowed animators to experiment with different styles. The quality of the animation was generally better than TV series and could occasionally rival that of feature films. Popular OVA included *Bubblegum Crisis* (1987–91), *Vampire Princess Miyu* (1988–89), Anno Hideaki's directorial debut *Gunbuster* (1988–89) and *Tenchi Muyo!* (1992–2005). If the anime proved successful enough, this could lead to more prestigious productions. Yūki Masami's manga *Patlabor* was released as a seven-episode OVA directed by Oshii in 1988 but its success led to a TV series and two feature films. OVAs also allowed the distribution of more outré material such as hentai (explicit – the term translates as 'weird attitude'), with anime such as *The Lolita Anime* (1984), *Cream Lemon* (1984) and *Urotsukidōji* (1987–1995) amongst the better-known examples.

The 1980s were also a time when many animators, who had learned their craft working on TV anime, were able to establish their own creative groups or studios. One of the primary motivations was to break free of the conventional studio system and produce work for which the creators would retain copyright. Oshii Mamoru joined the group Headgear and started working on productions such as *Patlabor*. The most famous of these independent studios is Studio Ghibli, established by Miyazaki Hayao and Takahata Isao who, after the success of Miyazaki's environmental adventure *Nausicaä of the Valley of the Wind* (1984), which is still looked upon with much affection in Japan, ploughed the returns from that film into setting up their own venture. Their aim was to produce the sort of animations they wanted to see as well as nurture talent for the future.

The 1980s were also a time when fans of manga and anime were able to start on the road to becoming professionals. Clamp are a circle of all-female manga artists who started producing

dōjinshi in the early 1980s, moving on to creating original works, becoming professionals in 1989. Many of their manga have made the transition to anime, including *Tokyo Babylon* (1993), *X* (1996), *Cardcaptor Sakura* (1998–2000), *Chobits* (2002) and *xxxHolic* (2008). Studio Gainax, originally called Daicon Film, was started by a group of university students, including Anno Hideaki and Yamaga Hiroyuki, in the early 1980s. After creating a series of short animations that were effectively fan works, screened at the annual Daicon conventions (Japan's National Science Fiction conventions), they managed to establish themselves as a small studio, and changed their name. *Royal Space Force: Wings of Honnêamise* (1987) was their first feature animation. Written and directed by Yamaga, it tells a story of a space flight pioneer, set in an alternative world on the brink of war, and featured an unconventionally un-heroic protagonist. It garnered critical acclaim but failed to light the box office.

Productions were also becoming grander in scale and the 1980s were a time when budgets started expanding and cinema releases were becoming increasingly ambitious. There were a number of productions based on classical Japanese literature, such as *Tale of Genji* (1986) and *Night on the Galactic Railroad* (1985). Studios were also more willing to experiment with different styles and formats. Ōtomo Katsuhiro's *Akira* (1988), based on his manga of the same name, cost over a billion yen, but every single one of them could be seen onscreen. Lavishly produced, the animation is utterly fluid and the lip-syncing matches the dialogue perfectly. *Akira* didn't recoup its budget at the Japanese box office but it was the film that received notable cinematic distribution in the West, bringing anime to the world. The early 1990s saw the bursting of Japan's bubble economy. The economic miracle was over and this had a knock-on effect for the anime industry. Consequently, many theatrical productions had to be scaled back.

TV studios continued to churn out episode after episode of productions of varying quality. Amongst the most popular were hyperactive martial arts anime *Dragon Ball* (1986–89), fluffy *Sailor*

Moon (1992–93), futuristic drama *Tekkaman Blade* (1992–93), the ubiquitous *Pokemon* (1997–), originally a videogame franchise, and *Yu-Gi-Oh!* (1998).

The most praised and contentious of the 1990s anime was Anno Hideaki's *Neon Genesis Evangelion* (1995), a post-Apocalyptic science-fiction story about a group of teenagers who pilot giant mecha to battle invaders known as Angels. Anno's aim was to revitalise the format as the ultimate otaku anime and he created something that was clearly influenced by anime of the 1970s but was itself entirely original, although the series was incredibly controversial. Its ending became increasingly cryptic, asking more questions than it answered, which annoyed many fans of the series. Additionally, TV studios began to clamp down on the depiction of violence and sexuality in anime. It meant that Watanabe Shinichirō's wonderfully hip *Cowboy Bebop* (1998) was censored on its original broadcast.

Evangelion did have an impact on anime production. An increasing number of series were produced post-*Evangelion* but these were more likely to be broadcast as late-night TV shows. Aimed at late-teen/20-something fans, these shows aired between 11pm and 4am and the purpose was to showcase new anime. These were often based on popular manga, video games or novels as well as original stories, and usually ran in series that were broadcast in discrete three- or six-month slots. Material that wouldn't be suitable for early evening viewing was therefore acceptable for late-night broadcast, although the stories didn't necessarily contain high levels of sex or violence. But it meant that *Cowboy Bebop* was finally shown in its entirety. Mecha anime such as *Garasaki* (1998–99) and *Brain Powered* (1998) were most obviously influenced by *Evangelion*, but more avant-garde fare was available too, such as *Serial Experiments Lain* (1998). Some anime, such as naughty adult-oriented comedy *Oruchuban Ebichu* (1999), which followed the trials of a slack OL's (office lady) housekeeping hamster, were only suitable for broadcast on satellite TV and, even then, were cut for content. Additionally, anime began to be broadcast by independent stations on UHF (the major TV networks transmitted on VHF).

These channels had fewer restrictions and were able to show more outré material although, again, this didn't need to be the case as the channels catered for a broad demographic. *Legend of Basara* (1998), *Elfen Lied* (2004), *Comic Party* (2005) and *The Melancholy of Haruhi Suzumiya* (2009) were shown on these stations, the latter becoming an enormous hit.

Feature films continued to be produced, many of them connected with popular long-running TV anime, such as *Doraemon*, *Dragon Ball*, *Sailor Moon*, *Crayon Shin-chan* and *Cardcaptor Sakura*. More thought-provoking fare in terms of their themes, narratives and style could be found in such films as *Ninja Scroll* (1993), *Memories* (1995), *Ghost in the Shell* (1995), *Jin-Roh: The Wolf Brigade* (1999), and *My Neighbours the Yamadas* (1999), which were all high-quality productions, offering an intelligent and diverse range of viewing. Studio Ghibli was thriving, with *Princess Mononoke* (1998) smashing the home box office and gaining attention in the West as well.

The 2000s have seen anime continue to flourish. Some of the popular anime from many years ago were revived and updated for a modern audience. The Gundam franchise had been long running, but *Mobile Suit Gundam SEED* (2002) and *Mobile Suit Gundam 00* (2007) were well received critically, and popular as well. Similarly, *Macross* was reworked as *Macross Frontier* (2008) and *Mazinger Z* revived as *Shin Mazinger Shōgeki! Z Hen* (2009). *Evangelion* was reworked as a series of four feature films, *Rebuild of Evangelion*. Other TV anime were derived from feature films or OVA. *Ghost in the Shell: Standalone Complex*, for example, revisited the *GITS* world and made for compelling viewing.

Popular manga continues to provide a rich source of content for TV studios keen to churn out weekly episodes of anime. These include franchises such as *One Piece* (1999–), *Naruto* (2002-07), *Bleach* (2004–12) and *Naruto Shippūden* (2007–), all based on manga which have been running for years, as well as completed stories such as *Fullmetal Alchemist* (2003–04/2009–10), *Mushishi* (2005–06), *Excel Saga* (1999–2000), *Death Note* (2006), *Fruits Basket* (2001) and *D-Gray Man* (2006–08).

Feature films were flourishing too, with prestige productions from the ever-reliable Studio Ghibli continuing to dominate the box office and the works of such distinctive directors as the late Kon Satoshi (*Millennium Actress* [2001], *Tokyo Godfathers* [2003], *Paprika* [2006]), Shinkai Makoto (*The Place Promised in Our Early Days* [2004], *5 Centimeters per Second* [2007]) and Hosoda Mamoru (*The Girl Who Leapt Through Time* [2006], *Summer Wars* [2009]) garnering critical acclaim. In addition, films such as Ōtomo's mind-bogglingly expensive *Steam Boy* (2004), Yuasa Masaaki's mind-boggling *The Mind Game* (2004) and American director Michael Arias's anime *Tekkon Kinkreet* (2006) demonstrated the range of product available for cinema viewing. Computer graphic imagery is becoming increasingly widespread and, although CGI has already been enhancing traditional cel-based animation for many years, fully CGI films are becoming increasingly prevalent, including feature films such as *Appleseed* (2004) and *Final Fantasy VII: Advent Children* (2005).

MARKETS AND DEMOGRAPHICS

There are three basic formats for anime. The best quality can be found in the feature films, more often likely to be standalone stories, which receive cinema releases. Then there are the OVA, effectively the direct-to-video anime. TV anime makes up the rest of the market. A significant proportion of TV anime is derived from manga as the source material. This has its advantages in that there is already brand recognition, an established market and an army of fans just waiting to view the anime, often on a weekly basis. The disadvantage, of course, is that, with a weekly production schedule, the quality of the animation may suffer and will definitely be inferior to feature films. Stories in the anime often move more quickly than the manga source and this may result in deviations from the mangaka's story or a number of the dreaded 'filler' episodes, which often comprise spin-off plots for particular characters or complete side-stories, detracting from the main narrative but providing enough material to keep the series airing until the source catches

up. The aim is to slake the fans' thirst for content and to maintain momentum for the series, but fans do not always appreciate these additional episodes. There are some instances when popular anime spawn manga series, such as *Wolf's Rain*. *Neon Genesis Evangelion* was conceived before its manga, although a comic was released before the TV series in an attempt to initiate public awareness.

Although the demarcation lines are not precise, the markets for anime and manga can be broadly defined into a number of sectors. These descriptions are very general – anime aimed at a particular market does not exclude other demographics. Indeed some shōnen manga/anime can cross over to become more shōjo oriented, and vice versa. The fact that manga/anime principally directed at the teen market can be very complex, sophisticated and occasionally quite dark, means that many adults will often follow stories ostensibly aimed at younger audiences.

'There are many characters which are imbued with enough depth to capture an adult's interest, and some which offer profound psychological insights and social circumstances that escaped us as children.'[2]

- Kodomomuke manga/anime is aimed at young children. The format generally comprises very simple characterisation and standalone episodes.

- Shōnen manga/anime is aimed at boys. They cover a wide range of genres, from fantasy, sci-fi, sport/martial arts, mecha and beyond. The heroes are plucky and often have a good heart, striving to achieve their goals. There's plenty of action and usually lots of humour, some of which can be quite bawdy.

- Shōjo manga/anime is aimed primarily at girls. Again, the subject matter is very broad and ranges from sweet, fluffy, high-school romances to dark supernatural fantasies and everything in between. Shōjo manga is most usually characterised by the wide-eyed heroine, often a teenage girl, who is usually kind and

compassionate, but may be a bit of an airhead. There will be plenty of male characters and there is often a love triangle at the heart of the story. The male characters are likely to have a bishōnen appearance – beautiful rather than handsome, even bordering on androgynous.

- Seinen are adult manga/anime for men. That doesn't necessarily mean 'adult' in the euphemistic sense of the word, although the stories may contain explicit sex and/or violence, and they are typically aimed towards 18–40-year-old men. Indeed, there are even manga/anime directed at 40-something salarymen. The themes and characterisation will be more complex than shōnen manga.

- Jōsei manga/anime is for women, aged from their late teens to forties. These stories have a variety of themes, generally aimed at women's concerns, and are not restricted to romance, although relationships are often important. The bishōnen male character will have beefed out a bit, and the heroine will usually be concentrating on developing herself as a person.

'Japan is a country that tolerates "childish culture" and "childish values". It is a culture in which the presence of adults at the game center and dozens of stuffed toys in someone's room doesn't strike us as peculiar.'[3]

There's an anime series for most genres and the format covers the gamut of markets from mainstream to highly specialised. In terms of multi-format marketing, anime offers an enormous diversity of product available for consumers. Although cross-marketing is extremely common in the West (for example, computer game spin-offs of films, fast-food character tie-ins, etc), the range of Japanese cross-media merchandising can be enormous. These include TV series, OVAs, live-action films, manga, video games, soundtrack CDs, drama CDs, novels, artbooks, fanbooks, databooks, theatrical/ musical spin-offs and, of course, action figures, plushies (cuddly

toys) and all manner of accessories. For example, *Prince of Tennis* started out as a manga in 1999 and was closely followed by an anime TV series, several OVA and even a feature film. Beyond these formats, the story has been adapted for no less than 20 stage musicals (known as TeniPuri Musical or Tenimyu), a live-action film, a radio show, multiple video games and, of course, a huge amount of merchandise. Ninomiya Tomoko's manga *Nodame Cantabile* (2001–09) features a burgeoning love affair between music college students. The manga became a live-action TV series in 2006 and then an anime a year later. The spin-offs were perfectly suited to the subject matter because of its classical music theme and soundtrack CDs were extremely popular. Similarly there were live concert tours and even a music conducting game on video games consoles. Products associated with anime can have a huge impact on its marketing. *Mobile Suit Gundam*'s popularity soared when Bandai distributed models of the robots. Even today, many fans of the series, who are now adults, are still passionate about building Gundam models. Cosplay (costume play) is also big business, with ready-made costumes for many characters from popular anime/ manga available to buy in shops. Some fans are incredibly creative and spend hours making their own costumes, proudly displaying their talents at the multitude of conventions dedicated to anime/manga.

ANIME STYLE

Japanese aesthetic sensibilities are both distinct and very different from those in the West. Contemporary pop artist Murakami Takashi, himself enormously influenced by manga and anime, published a 'superflat' theory in 2001 which expressed how Japanese society has effectively 'flattened' by becoming increasingly superficial in the years following the Second World War. It reflects Japan's assimilation of Western culture such as comic books and cartoons, whilst acknowledging the legacy of traditional arts such as ukiyo-e, which are very two dimensional and representational, a contrast to Western art which emphasises the representation of

perspective. Stylistically, anime preserves this two-dimensional approach and most anime generally have a style that demonstrates no particular requirement to create a sense of depth or to convey three dimensions. Presentation and symbolism seem to be more important than realism. As Donald Richie states, 'Japan has no tradition of the common style known as realism, the style that Susan Sontag has defined as "that reductive approach to reality which is considered realistic" [...] What passes for realistic in Japan, elsewhere is thought highly stylised.'[4]

Character design in anime is extremely important to the overall aesthetic. Character culture is something that is ingrained within Japanese society. A 2004 survey by the Bandai Character Research Centre revealed that 79 per cent of respondents owned character products and over 90 per cent admitted to liking particular characters. Anime and manga are prime sources of this interest in characters, probably because they have been a fundamental part of people's lives. 'At the root of this love for characters… is a unique aesthetic sensibility that is informed by a receptivity and fondness for planarity, abbreviation, symbolism and simplification.'[5] The characters developed with the post-war baby boomers and remained with them even as they became adults and had children of their own. It links with Japan's indigenous religion, Shintō, which recognises kami (sacred spirits, often referred to as gods) that exist in all things.

Ironically, whereas the medium of animation is often used to depict stories that might (certainly before the age of CGI) be challenging or horrendously expensive to achieve via live action – complicated fantasy sequences or anthropomorphic animals, for example – it is common to see anime that could have been filmed as live-action pieces. Stories such as *Only Yesterday* or *Tokyo Godfathers* are set in the real world and could easily have been filmed with actors on location. However, the production costs are much lower with anime and the complicated practicalities of filming, such as recreating historic sets, can therefore be eliminated. Producing the story as an anime can offer the director an alternative form of creative freedom.

In many respects, where anime are derived from manga, the animation has a ready-made storyboard and the job of creating the narrative flow and the pacing lies with the director. The fluidity of the animation will not always be continuous and there may be a variety of styles used. Film runs at 24 frames per second, so the highest-quality animations will produce 24 separate images for every second of animation to ensure the most natural and realistic portrayal of motion possible. However, most TV animation is filmed at 12 or even 8 frames per second to keep production costs down. With enough time, money and resource, the most beautifully intricate and detailed animations can be produced, but the burden of churning out 25-minute episodes of TV anime every week will take its toll on the quality of the finished product.

Animators realised early on that focusing their attentions on key scenes could make the production appear more prestigious and costly than it actually was. Hence the most important scenes would be animated with great attention to detail, while, for other parts of the story, the animators developed a variety of tricks to convey movement cheaply – sometimes, paradoxically, in action sequences. For example, in Takahata Isao's *Horusu Prince of the Sun* a rat invasion of the local village is depicted using a series of static images, rostrum camera panned to give some sense of movement. Repetition of key sequences is very common, particularly in TV anime. While Usagi's 'Moon Prism Power Make-up' transformation into Sailor Moon is highly detailed in its animation, the same sequence is used in every episode. *xxxHolic* depicts background characters simply as outlines and, although they are animated, they are pure white, with no colour shading at all. It's cheap but, if executed in a way that is consistent with the style, often very effective. *Neon Genesis Evangelion* became increasingly abstract as the story progressed; indeed, it was astonishing that watching static images of a boy encased inside a giant robot, coming to terms with his very identity, could make for such compelling viewing. The Japanese love using short-hand means of expression and these can be seen in both manga and anime. The Japanese language is

extremely functional and, because of the number of homophones, is often contextual. Words are reduced, simplified and abbreviated – for example, a 'personal computer' becomes a 'pasokon', just as 'animation' is reduced to 'anime' – and to some extent this is reflected in the way that TV anime occasionally provides short-hand characterisation. This is a trick derived from manga, using certain visual devices which can quickly convey emotion; for example, sweat drops to indicate nerves, blushing to show embarrassment, stress denoted by a sort of cruciform located near the forehead which represents a pulsing vein, arousal taking the form of nosebleeds. The character may also be distorted into chibi (super deformed) form – effectively a caricature – which demonstrates heightened emotion, particularly anger, fear, surprise or shock. These short-hand devices have additional functions, often injecting instant humour to proceedings.

Japanese narrative constructions are subtly different to Western plot structures. Almost paradoxically, where the role of the benshi was to explain and inform, many of the more sophisticated anime launch straight into the story, sometimes without any exposition, leaving it up to the viewer to develop their own interpretation. *Wolf's Rain* presents a fantasy world but starts off in a familiar city and introduces a plethora of characters; it takes several episodes of viewing before we recognise who the main protagonists are and engage with them. About half way through the series, when it has established itself, the episodes return to the start of the story, telling it from each wolf's perspective. It could be argued that it's a cheap means of padding out the running time but this misses the point. It actually reinforces our perceptions of the characters and enhances our understanding of their motivation. Experience over narrative is sometimes far more important in long-running anime. Sometimes endings can be obscure, ambiguous or inconclusive. There is a need in mainstream Western narrative structure, particularly Hollywood cinema, for conclusions to be reached and for all outstanding plot issues to be resolved (more often than not with an irritatingly predictable 'happy' ending). That is not the case

with much of Eastern cinema, anime included. When immersing oneself in several episodes of a TV anime the journey is often as important as the destination.

IMPORTANCE OF ANIME IN JAPANESE CULTURE

Anime and manga are quintessentially Japanese art forms and therefore present a fascinating window on the country's society. Despite the increasing homogenisation of world culture, Japanese society has managed to retain its customs, practices, language, food and etiquette and, as a result, Japanese history, culture and elements of everyday life feature strongly in anime. The neon cities and bōsōzoku bikers of *Akira* reveal as much about city life in the late 1980s as they do about the future depicted in the narrative. The incessant chirruping of the cicadas in *Neon Genesis Evangelion* are as important to the mise-en-scene as the fantasy elements, such as the vast city that can be lowered beneath the surface of the earth should an Angel attack. The gentle *Sazae-san* (1969–present) looks at life in a decent and hard-working traditional Japanese family. Japan's overworked businessmen are depicted in *The Laughing Salesman* (1989–92), where each episode sees the titular character strike a pact with some hapless salaryman, which inevitably ends in their downfall. Daily life at high school can be seen in many anime aimed at younger audiences; *Ocean Waves* (*Umi ga Kikoeru* [1993]), *Kimagure Orange Road* (1985) and *Whispers of the Heart* (*Mimi wo Sumaseba* [1995]) show us many aspects of school life. *Chobits* (2002) and *Sailor Moon* feature Japanese cram schools where underachieving pupils spend their summers desperately trying to stuff themselves full of information in order to get a place at a good university.

Arts and literature can be found in adaptations of literary works. Anime can be based on folk tales, such as Momotarō, or legends such as Kawamoto's *The Demon*, which was based on *Konjaku Monogatarishū*. Novels, too, provide a rich source of inspiration – *The Tale of Genji* by Murasaki Shikibu, *Life of an Amorous Man*

by Ihara Saikaku, *Night on the Galactic Railroad* and *Goshu the Cellist* by Miyazawa Kenji are all classics of Japanese literature. Adaptations of modern novels can be found in such anime as *Grave of the Fireflies* by Nosaka Akiyuki, *Sky Crawlers* by Mori Hiroshi or *The Girl Who Leapt Through Time* and *Paprika* by Tsutsui Yasutaka.

Japan's history, either mirroring actuality or represented in a fantastical or anachronistic context, is presented in a number of productions. Fantasy productions, from the *jidaigeki* (period drama) genre range from *Ninja Scroll* (1993) and *Rurōni Kenshin* (1996–98) through to *Princess Mononoke* (1998). Anime based on historical events include many films centred around World War Two, such as *Barefoot Gen* (1983) and *The Cockpit* (1993).

The apocalypse is a common theme in anime. Connected with Japan's history as the only country on which nuclear weapons have actually been used, the horrific bombings of Hiroshima and Nagasaki have had a clear influence on many productions. *Cowboy Bebop*, *Fist of the North Star* (*Hokuto no Ken* [1984–87]) and *Megazone 23* are but a handful of anime that begin after the end of the world.

Japan has two major religions, Shintō and Buddhism. Shintō's pantheon of kami feature in anime, as do creatures from folklore. Perhaps the most common of these are tanuki (raccoon dogs, often associated with fun and mischief), kitsune (fox spirits, known for their cunning), okami (wolves) and tengu (crows), but also kappa (water spirits), oni (demons, which are not necessarily evil) and yōkai (general spirits of which there are an inordinate variety).

ANIME GOES WEST

Anime has been exported overseas from early on in its history. The primary market was initially for children's TV shows – as broadcasters snapped up cartoons to fill the programme schedules in the early evenings and Saturday mornings. Anime for children created in the 1960s and 1970s reached Western shores just a few years after their initial releases, albeit in horribly dubbed versions, and they were often heavily edited. Among the wave of titles that traversed the seas were

Marine Boy (1965), *Astro Boy, Kimba The White Lion* (*Jungle Emperor* [1965–66]), *Battle of the Planets* (*Science Ninja Team Gatchaman* [1972]) and *Speed Racer* (*Mahha GōGōGō* [1967–68]). However, there were some misunderstandings for Western broadcasters and audiences, due to variations in the perception of what was acceptable viewing material for children in different countries. The Japanese tolerance of violence in fantastical settings and mildly salacious scenes to add naughty humour to proceedings caused issues for many Western TV stations. Many series were censored to appease viewing audiences who didn't approve of the material.

Video distribution companies recognised the revenue potential of home video in the mid to late 1980s and early adopters started distributing anime in video shops, primarily with material targeted at the children's market. Slowly, increasing quantities of Japanese animation became available in the West, including material aimed at a wider demographic. However, sometimes very little attention was given to the work's artistic significance. For example, Miyazaki's *Nausicaä of the Valley of the Wind* (1984) was renamed *Warriors of the Wind* and marketed as a fantasy film. Much of the running time was mercilessly excised leaving just some gorgeous animation to show the greatness that was once there amidst a thoroughly confusing plot. This resulted in Miyazaki withdrawing his films from being distributed in the US for many years and insisting on increasingly rigorous restrictions on the way subsequent releases were presented. Similarly, *Wings of Honnêamise* was released in the West as *Star Quest* in 1987, with altered character names, shuffled scenes and dreadful dubbing.

It was still difficult to see animation that was suitable for adults but groups of fans, who recalled enjoying anime as children, began to swap VHS tapes of films and programmes from Japan. Their luck changed when *Akira* was distributed in cinemas in the early 1990s, albeit with a limited release on the art-house circuit, but it was, to Western eyes, unlike anything that had been seen before. An intelligent science-fiction story about biker gangs, telekinesis, the decay of society, even the possible annihilation of a city. Sadly,

Akira's cinematic release was not to be repeated, at least initially. *Ghost in the Shell* and *Princess Mononoke* also received cinematic distribution, although again they were generally distributed in repertory cinemas, and anime would predominantly remain on the small screen and in the realm of the aficionado. Anime conventions started in the 1990s and became increasingly popular. Eventually video and computer technology became available which allowed fans to import copies of their favourite anime and then subtitle unlicensed copies. These fan subs were produced with very great care and attention to detail, often explaining particular idioms or cultural references. Although they were strictly breaching copyright, they were generally not distributed for profit. Many fan communities were conscientious about withdrawing unlicensed material once properly licensed versions had been released. It was all about getting to see the anime. The evolution of the Internet also facilitated distribution of anime and has significantly contributed to its growth in popularity.

Eventually the fan culture reached a critical mass and distribution companies saw the potential to market the material in the West. The DVD format helped, because it was able to offer a choice of animation – either Japanese language with subtitles or dubbed versions in that country's home language, cutting production costs and satisfying all its potential audiences. Anime such as *Pokemon, Dragon Ball* and *Sailor Moon* found their way across the ocean and started achieving high ratings. *Pokemon* was a phenomenal success. Initially a video game inspired by its creator Tajiri Satoshi's love of collecting insects (a passion of Tezuka Osamu's as well), it was hugely popular in Japan but, more importantly, captured the imaginations of youngsters in the West. Ostensibly the story of a young boy who captures Pokemon (creatures with special powers, derived by combining the terms 'pocket' and 'monster' – *Poketto Monsutā*) and trains them to battle other Pokemon, it had a plethora of imaginative characters, in what amounted to a formulaic plot structure.

The acceptance of anime in the West was not without controversy. Most notable was that of *Urotsukidōji: Legend of the Overfiend*. Originally a multi-part OVA, it was edited into a fairly

incomprehensible two-hour version and distributed on video. In the UK it was further cut by over two minutes by the BBFC. The problem was that attitudes in the West continued to be centred around animation being targeted at children and *Urotsukidōji* was about as far from suitable for children as it was possible to get. Hentai can be violent and pornographic. *Urotsukidōji* was violent and pornographic. Although there is a significant market in Japan, hentai is specialist viewing and certainly not representative of anime's output. But although *Urotsukidōji* may have pushed back anime's mainstream acceptance in the West, it may also have enhanced the format's cult status amongst fans.

These days, anime is part of the mainstream – there is a broad understanding and acceptance of the form, evidenced by the fact that all the major video retail stores have sections dedicated to the format. Worldwide recognition of the art form was confirmed in 2002 when *Spirited Away* won the Best Animated Feature Academy Award and the Golden Bear at the Berlin Film Festival. Indeed, both *Spirited Away* and *Princess Mononoke* feature in the Internet Movie Database's top 100 films of all time (as voted by viewers). Anime is thriving worldwide.

GLOSSARY

Anime Japanese animation

Manga Japanese comic book

Mangaka Someone who writes/draws manga

Dōjinshi A self-published work, some original material, sometimes fan based *aniparo* (a parody of existing manga/anime characters) which are printed though easily accessible services in Japan. These works are usually distributed via conventions, the largest of which can have hundreds of thousands of attendees. Some dōjinshi authors/artists make the transition to commercial publishing.

OVA Original Video Animation – anime produced for the direct-to-video market rather than for TV or cinema release. Sometimes known as OAV (original animated video) – the terms are interchangeable – the quality of the animation is generally better than that of TV series.

Otaku Geek or nerd. Originally meant as a term to define any kind of obsessive hobbyist, its use has changed over the years. It used to be a term of derision but is sometimes regarded as a badge of pride amongst anime aficionados. Otaku are stereotyped as being male obsessive collector types without (real) girlfriends, a propensity for visiting 'maid bars', hanging around Akihabara (Tokyo's electronic gadget and geek magnet metropolis) and having mercurial knowledge about whatever anime/manga they love.

SD Super-deformed: a stylised parody design featuring childlike versions of characters often with extra-large heads – a transition to cartoon form. SD is often used interchangeably with Chibi, meaning 'small person'.

Mecha	Piloted robot suits
Shōnen	Manga/anime generally aimed at boys
Shōjo	Manga/anime aimed at girls
Josei	Manga/anime aimed at adult women
Seinen	Manga/anime aimed at adult men
Kodomomuke	Anime/manga for young children
Hentai	The seedier side of anime, normally OVA releases that can be highly pornographic or violent.
Yaoi	Also known as Shōnen-ai or Boys' Love (BL), this relates to media depicting relationships between men. Often created by women for women.
Yuri	Also known as Shōjo-ai, this relates to media depicting relationships between women.
Ukiyo-e	Woodblock prints
Noh	Highly formalised classical Japanese theatre
Kabuki	Traditional Japanese theatre
Oni	Demons
Yōkai	Spirits
Shintō	Japan's indigenous religion. (Buddhism is Japan's other main religion.)

KEY ANIME CREATORS

This section aims to provide brief biographies and overviews of the works of ten key anime directors. With reluctance, some great talents such as Matsumoto Leiji, Tomino Yoshiyuki, Sugii Gisaburō, Dezaki Osamu and Kawajiri Yoshiaki, amongst others, have not been included, due to a lack of space. However, we have tried to include some of their important works within the review section of the book.

TEZUKA OSAMU (1928–89)

'The best part is being able to make things up...'[6]

If there is one single person who has influenced the enormous success of both anime and manga it has to be Tezuka Osamu. His distinctive style, storytelling ability and innovative approach to characterisation resulted in him becoming known throughout Japan as the God of Manga.

Born in Ōsaka prefecture in 1928, Tezuka grew up in Takarazuka City, which was famous for the Takarazuka Revue, an all-female theatre troupe renowned for its romantic musicals (the male roles are taken by actresses, the otokoyaku), and Tezuka visited the revue on many occasions. Their performances would be hugely influential on his work. He grew up in a happy environment for, although he was bullied at school for having unusually curly hair, he received

support from his family, which helped develop his confidence. Naturally creative, he loved telling stories and started drawing comics whilst still at elementary school. During the Second World War he developed ringworm and became seriously ill. Inspired to become a doctor, he started training at medical college but couldn't escape his love of drawing. So he joined the Kansai Comic Artists' Club where he was asked by fellow member, Sakai Shichima, to create a comic based on one of his stories. This was *New Treasure Island* and was published as an akahon. It led – eventually – to Kato Kenichi, Tokyo-based editor of *Manga Shōnen* magazine, giving the young artist his first professional break as a mangaka, producing a serial featuring a lion cub called Leo. *Jungle Emperor* (*Jungle Taitei*) ran from 1950 to 1954. Tezuka's next creation, *Astro Boy*, his most famous character, started its manga run in 1952. Its success led to Tezuka, who had recently graduated from medical school and was commuting regularly between Ōsaka and Tokyo, having to decide where his future lay – manga or medicine? A fully qualified doctor, he was advised by his mother to choose what he really *wanted* to do, and decided upon manga. He didn't neglect medicine entirely, though; he created the character *Black Jack* (1973–83), a mysterious and highly skilled surgeon.

> *'This is the way my ideas work. An interesting idea emerges through crazy combinations.'*[7]

Tezuka was an innovator with both his character design and storytelling. A visual feature that many newcomers to manga and anime first notice is that the characters often have unusually large eyes – they are often kawaii (cute). Tezuka pioneered this approach to character design because he recognised the extent to which large eyes can more easily convey emotion. And, actually, he was inspired by Western characters such as Betty Boop and Mickey Mouse. Early on in his career he developed a star system, whereby he would rate his protagonists, noting their characteristics and allowing them to make cameo appearances in other stories.

He also adopted the visual language of the movies, borrowing from composition and editing techniques, to tell his stories in a dynamic and exciting style. He was heavily influenced by the European films he watched in his youth and used cinematic techniques, including close-ups and unusual angles, to capture the expressions and emotions of the characters.

But, importantly, Tezuka was also a pioneer of anime. He started out working for Tōei studios, but set up his own animation company, Mushi Productions in 1961 (the name derived from the kanji character for 'insect' from which he derived his pen-name, reflecting his life-long fascination with the creatures). Many of his manga creations made the transition to the small screen, including *Astro Boy*, *Jungle Emperor* and *Princess Knight* (1967–68), the story of a princess who has to pretend to be male in order to ascend the throne. Mushi Productions also produced anime from other authors' source material. Quick to recognise that the format was not only suitable for children, the company produced a number of anime targeted at older audiences. *Ashita no Joe* told the story of a delinquent who made it big in boxing. Adult anime, which didn't balk on the depiction of sex, could be found in *Arabian Nights* and *Cleopatra*.

One of Tezuka's long-running works was *Buddha* (1972–83), an interpretation of the life and spiritual journey of Indian prince Siddhartha, who becomes 'the Enlightened One', Gautama Buddha. A lengthy manga of over 14 volumes, it was an occasionally unsentimental portrayal of a historic character, and made the transition to anime only recently, in 2011. Tezuka's magnum opus was *Phoenix* (*Hi no Tori* [1956–89]), a manga more than 30 years in the making which remains uncompleted. The primary theme of this series of interconnected standalone stories was that of reincarnation, the blood of the titular bird thought to contain the secret to immortality. Phoenix was adapted into two anime films and an OVA in the 1980s, and a TV series in 2004.

Just after the war Tezuka was beaten up by a bunch of GIs from the American forces occupying Japan. He never really understood why this happened, other than to recognise that understanding

people came from being able to communicate with them. Perhaps this experience explains why his stories are so human. As well as his ability to create comic characters and comedy stories, he was also strongly aware of manga and anime's power to convey all human emotion – anger, fear, hatred, joy – and he wasn't afraid to conclude his stories on a downbeat note. Combining a remarkable imagination and unique storytelling ability, as well as a profound understanding of genre, it is easy to see how he became so influential and so revered. Tezuka died in 1989, aged 60.

TAKAHATA ISAO (b 1935)

Although not as revered outside Japan as his Studio Ghibli co-founder Miyazaki Hayao, Takahata Isao is a director whose stories are often set in the real world with occasional forays into the fantastical. His body of work encompasses all human emotions but he combines this with a strong need to experiment with the animated form. He decided to become an animator when he saw the French animation *Le Roi et l'oiseau* (started 1948, completed 1980) and was impressed by the artistic possibilities that animation afforded. He started his career at Tōei studios, where the animation department was run rather like a factory and the artists working there formed a strong union. It was through union activities that Takahata met fellow animator Miyazaki Hayao. Initially working on TV anime, Takahata's debut feature was the groundbreaking *Horus: Prince of the Sun* (*Taiyō no Ōji: Horusu no Daibōken* [1968]), a mythological tale with a strong socialist subtext, about a boy on a quest to re-forge a magical sword that will save his village from an evil sorcerer. Unfortunately, it failed to ignite the box office, he was demoted and eventually left Tōei. He worked on TV anime for several years (sometimes collaborating with Miyazaki) on anime such as *Heidi, Girl of the Alps* (1971), *Anne of Green Gables* (1979) and the delightfully brash *Chie the Brat* (*Jarinko Chie* [1981]). Takahata's directorial skills really came to the fore in the charming *Goshu the Cellist* (1982), a feature film based on the novel by Miyazawa Kenji,

one of Japan's most beloved novelists. It tells the story of Goshu, the worst musician in his orchestra, who improves his technique with the help of local animals. Despite the anthropomorphism of the animals, which has the potential to appear tacky, *Goshu* is actually a delightful little film that is beautifully animated.

After Takahata was invited to co-found Studio Ghibli, his first feature for that company was the haunting World War Two story, *Grave of the Fireflies* (1988), one of cinema's most heart-rending experiences. It tells the tale of a brother and sister trying to survive the last few months of the war, following the bombing of Kōbe. It was released as a double bill with Miyazaki's delightful *My Neighbour Totoro* and won international critical acclaim. *Only Yesterday* (1991), derived from Okamoto Hotaru and Tone Yuko's nostalgic josei manga, sees an office lady, Taeko, taking a holiday with her relatives in the countryside and looking back on her life as a schoolgirl in the 1960s, comparing her present lifestyle with the Japan of her childhood. As a drama about growing up it contrasts modern cosmopolitan city life with rural living. It could have worked just as well as a live-action piece, but this is one of anime's strengths – it is unrestricted in scope and filmmakers can ensure that they have total control over their art; in this case recreating the everyday rather than the fantastical. But fantastical sources can serve as metaphors for the most human of stories, as is the case with Takahata's next film *Pom-Poko* (1994), which features *tanuki* (raccoon dogs) that metamorphose into human form in order to save their forest home from destruction. Takahata's last film to date was *My Neighbours the Yamadas* (1999), a series of sketches based upon Ishii Hisaichi's *yonkoma manga* (a four-panel comic strip similar to, say, *Peanuts* or *Dilbert*) – a difficult format to convert to feature film, although not without precedent. Following the exploits of a somewhat dysfunctional family, this is a comedy which revels in its depiction of Japanese life. With cultural references aplenty, including traditional stories re-imagined for the Yamadas and scenes interspersed with haiku from famous poets, it also uses innovative animation techniques to mimic the feel of being drawn directly on paper.

Takahata received his degree in French Literature from the University of Tokyo in 1959 and has, in recent years, combined his love of animation with his linguistic skills to translate a number of French animations into Japanese, including, of course, *Le Roi et l'oiseau*.

MIYAZAKI HAYAO (b 1941)

Perhaps the best known of all anime directors, Miyazaki Hayao's films are admired all over the world for their breathtaking artistry and engaging storylines. Not only are they huge box-office hits (they are amongst the most financially successful non-English-language films of all time), they are also critically acclaimed. Miyazaki is absolutely uncompromising when it comes to realising his artistic vision. His films are childlike in their quest for wonder and discovery – wonderful flights of imagination that are suitable for everyone.

Miyazaki's career in anime began in 1963, when he started working for Tōei after graduating in political science and economics from Gakushuin University. He met Takahata Isao at Tōei and they worked on a number of productions together, including *Horusu: Prince of the Sun*, before moving to other studios. Miyazaki worked on some of the World Masterpiece Theater productions as well as the TV series *Future Boy Conan* (1978).

Miyazaki's big break came when he was asked to direct a feature film spin-off of *Lupin III: The Castle of Cagliostro* (1979), a rip-roaring adventure, full of fast-paced action and slapstick comedy. It featured roguish hero Arsène Lupin, accompanied by an assortment of sidekicks, who attempts to break into a virtually impregnable castle to source the origin of forged banknotes. Although *The Castle of Cagliostro* was a hit, Miyazaki returned to working for television, filling the time between projects by developing a science-fiction manga, *Nausicaä of the Valley of the Wind*, on an ad hoc basis for *Animage* magazine. The comic proved immensely popular and eventually *Animage*'s parent company agreed to finance a feature film based on the still incomplete work.

Nausicaä was a huge success and it paved the way for Miyazaki to establish his own animation studio – Studio Ghibli – with Takahata and producer Suzuki Toshio. The aim was to free them of the artistic constraints imposed by the big studios. Ghibli's first film was *Laputa: Castle in the Sky* (1986), a tale loosely inspired by Swift's *Gulliver's Travels*. Featuring islands in the sky, giant robots, plundering pirates, evil villains and a sweet burgeoning relationship between the young protagonists, it is a marvellous adventure story. Miyazaki followed this with his masterpiece *My Neighbour Totoro*, a delightful fantasy about two little girls who befriend a woodland spirit. *Kiki's Delivery Service* (1989) told the tale of a young witch, one in a long line of Miyazaki's plucky and cheerful heroines, who, according to witch tradition, has to leave home with her talking cat Jiji, to begin her training. She starts a business delivering parcels on her broomstick, using her prodigious flying skills, in the town where she decides to settle. A coming-of-age film, it's about a young girl finding the confidence to make a life for herself. *Porco Rosso* (1992), a film about a flying pig who used to be a man, celebrates Miyazaki's lifelong love of aviation. Set in the Mediterranean in the 1930s it is reminiscent of Hemingway combined with Hollywood war movies of the 1930s and 1940s. But with a primarily porcine protagonist.

Princess Mononoke (1998) was a much more mature film and had a darker tone. An eco-fable set during a time when the gods roamed amongst the people, it follows the quest of a young man to discover the cause of a sickness that is afflicting his lands. The spirits range from the hordes of tiny ghostly kodama to the mighty and majestic Shingami, the deer god. Miyazaki constructs a complex political picture of the times, highlighting the conflicts between human industrial development and the need to respect the environment (and its spirits). Powerful and sophisticated viewing, it was the biggest box-office hit in Japan until it was surpassed by Miyazaki's next film – *Spirited Away* (2001).

Miyazaki had vowed to retire from directing on a number of occasions, as a result of the long hours and painstaking work involved with realising his visions, but he returned to make *Howl's*

Moving Castle (2004), adapted from the book by Diana Wynne Jones. It follows the story of cheerful milliner Sophie, who is turned into an old woman by the wicked Witch of the Waste following a brief encounter with narcissistic wizard Howl, in a world on the brink of war. Like *Spirited Away*, *Howl's Moving Castle* is a very human film about identity and acceptance; how lives can be turned upside down in a matter of moments and how best to deal with circumstances that we cannot control.

Ponyo on the Cliff by the Sea (2008) marked a return to the more child-friendly pictures of *My Neighbour Totoro* or *Kiki's Delivery Service*. It's the charming tale of a fish who befriends a young boy and decides that she wants to transform permanently into a little girl.

Miyazaki's films are delightful fantasies that explore the conflicts between humankind, nature and technology. Using strong characterisation, even with his minor characters, his heroes and, notably, heroines, are always brave and have a deep understanding and respect for the communities in which they live. A love for the natural environment and a passion for flying machines are themes that pervade his work. With fastidious attention to detail, his use of traditional, predominantly cel, animation techniques gives his films a timeless quality. They are guaranteed to be hits at the box office, but his vision as a director is never compromised.

RINTARŌ (b 1941)

Rintarō is the nom de plume of Hayashi Shigeyuki, an anime director who has been working in the industry for over 50 years. He started his career with Tōei as an in-betweener (the assistant to the lead animator who draws the frames between the key drawings) on *Hakujaden*. He moved across to Tezuka's Mushi Production studio and got his directorial break on the TV series *Astro Boy*. It was hard work churning out episode after episode and they regularly worked long hours, sometimes even 24-hour days. He continued to work for the studio for some years, on series such as *Jungle Emperor*, before leaving to become a freelancer. He co-founded the studio Madhouse

in 1972 along with Dezaki Osamu, Kawajiri Yoshiaki and producer Maruyama Masao, although he was never tied to the company and continued to work for other animation studios as well.

Rintarō directed a number of TV series in the early 1970s, including *Moomin* (1972) and racing car anime *Arrow Emblem: Hawk of the Grand Prix* (1977) as well as collaborating with Tezuka on *Jetter Mars* (1977), a sort of (inferior) reworking of *Astro Boy*, for Tōei. *Space Pirate Captain Harlock*, another Tōei production based on the manga by Matsumoto Leiji, ran for 42 episodes in 1978 and was a space opera featuring a dashing hero who is both honourable and rebellious. It gave Rintarō the opportunity to show his visual flair with wonderfully realised scenes of space travel and alien landscapes but also to develop really strong characterisation for both his hero and the supporting cast.

Rintarō's first feature film was the delightful *Galaxy Express 999* (1979), an adventure in space (featuring a cameo from Captain Harlock), which he followed up a couple of years later with *Adieu Galaxy Express 999* (1981). He continued the science-fiction theme with *Harmagedon* (1983) based on the manga *Genma Taisen*, which brought together the psychic talents of the Princess of Transylvania, a cyborg and a high-school student, amongst others, to save the world from alien destruction.

The Dagger of Kamui (*Kamui no Ken* [1985]) marked a departure from the science-fiction theme. Set in the 1800s, it follows the story of Jiro, a young man who trains as a ninja following a childhood drenched in tragedy, and then sets out on a long journey to discover his past and avenge his family. A complex and moving drama, it is also notable for its depiction of the Ainu, Japan's native people.

Rintarō worked on a number of OVA during the late 1980s and early 1990s, including an adaptation of *Bride of Deimos* (*Deimosu no Hanayome* [1988]), the four-part supernatural fantasy, *Doomed Megalopolis* (*Teitō Monogatari* [1991-2]), and two *Spirit Warrior OVA* (*Peacock King* [1988 and 1994]) about the demon hunter monk Kujaku. Showing an interest in a diverse range of subjects and styles, Rintarō directed a segment, *Labyrinth*, from the portmanteau

film *Neo Tokyo* (1987), the segment forming the framing device for the other two stories within the anthology, and *X* (1999), an adaptation of the supernatural shōjo manga from Clamp. For *Metropolis* Rintarō brought together the talents of Tezuka (story) and Ōtomo (screenplay), with a heavy dose of inspired retro visuals from Fritz Lang's film of the same name. Apparently Tezuka had never wanted to transform his story into an anime himself because he had concerns about the nature of the plot. Although Rintarō loved Fritz Lang's *Metropolis* (1927) and is clearly influenced by the style of that film, he claimed that he wanted to be true to Tezuka's story and 'communicate his spirit.'[8]

Never one to be left behind the times, Rintarō directed Madhouse's first fully CGI 3D anime *Yona Yona Penguin* (2009) at the age of 68. It is his willingness to embrace different ideas and styles, combined with the astonishing attention to detail in his work, that means he has constantly been in demand as a director.

OSHII MAMORU (b 1951)

Oshii Mamoru is an animator, mangaka, writer and director who uses the medium of animation (and sometimes live-action cinema) to discuss the nature of being and the intellectual pursuit of understanding what it is to be human. In the evocative worlds that he creates, he asks powerful philosophical questions about identity and meaning. But, while his films often feature scenes of introspection, Oshii makes sure to interrupt these musings with exhilarating action sequences. These cerebral elements (and not simply in the biological definition of cerebral but also incorporating scientific and technological perspectives) do not detract from his narratives or character development but rather add to the richness of the works he creates. The conclusions to his films are often – deliberately – ambiguous.

Oshii began work in the anime industry as a storyboard artist, working on a number of TV series including the popular *Yattaman* (1977–79) and *Zendaman* (1978) spin-offs from the *Time Bokan*

series before rising through the ranks to become a director for the anime adaptation of Takahashi Rumiko's immensely loved series *Urusei Yatsura* (1981), eventually directing the first two feature films that saw the series' televisual exploits hit the big screen. Oshii also became more involved with writing screenplays and manga. He is widely credited with creating what is considered to be the first OVA, *Dallos* (*Darosu* [1983]), a science-fiction series depicting mankind's relocation to the moon and the conflicts between the authorities and a group of guerrillas who consider themselves oppressed in the new society. Oshii then went on to create the surreal and ethereal *Angel's Egg* (*Tenshi no Tamago* [1985]) which has a highly distinctive visual style and minimal dialogue. Deliberately ambiguous, some of the themes that have come to typify Oshii's work can be seen in this film.

Joining the artist group Headgear, Oshii directed the TV series, OVA and feature films of *Patlabor* (1989), which linked themes of commercialisation and industrialisation with serious examinations of the psyche. Set in the near future, robots have become very much integrated within society: construction activities are carried out by worker robots, Labours, while the Tokyo police department employs robots to deal with crime. This intelligent science-fiction drama incorporated themes of machine sentience and was set in an utterly plausible future but, crucially, it was a drama with strong characterisation and a surprising amount of humour. Two feature film spin-offs of the series were made in 1989 and 1993. This combination of a credible future society with fantastical elements of enhanced technology would reach their zenith in the critically lauded *Ghost in the Shell* (1995), based on Shirō Masamune's manga, which added android terrorism to the mix to depict a future world where humans have chosen to enhance themselves with technology and intelligent machines have an increasingly important role in society.

Oshii's live-action film *Avalon* (2001) was a Polish-language film that reflected some of the non-anime inspirations behind his work, predominantly the photographic science-fiction art classic *La jetée* (1962) by Chris Marker.

Ghost in the Shell 2: Innocence (2004) followed Batou and Togusa from the original film as they investigated the murder of humans by 'sexadroids', androids designed to be sex toys for the wealthy. It discussed the acceptance of computers in modern society together with fears about their inappropriate appropriation by corporations, as well as the socialisation of technology and the disclosure of technologically enhanced abuse. The fact that, of the two main protagonists, one is nearly completely human and the other virtually entirely cyborg, asks deep questions about both the nature of humanity and the intelligence of technology. Furthermore, Oshii really makes you care for the characters – android or human – and the predicaments they face. *The Ghost in the Shell* universe continued with the TV series *Standalone Complex*. Oshii went on to adapt Mori Hiroshi's novel *The Sky Crawlers* (2008), a complex story set on an alternative earth where adolescent pilots fight wars for corporations.

The existence of being and perceptions of self are subjects that fascinate Oshii. Combining artistic and philosophical themes with engaging, character-driven narratives, his work is intelligent, sophisticated and complex and usually demands multiple viewings. Added to this are his impeccable designs for both character and setting, along with detailed animation, which just adds to the depth of his output. Look out for his basset hound, which makes an appearance in most of his films, sometimes even becoming a supporting character.

ŌTOMO KATSUHIRO (b 1954)

The work of Ōtomo Katsuhiro, not only as an anime director, but also as a mangaka and screenwriter, has been vital in bringing anime to Western audiences. His rise from underground manga artist to animator of Japan's most expensive productions lay with his magnum opus *Akira*. There are a number of themes that pervade his work. His protagonists are often those marginalised within society – the young or the old – and, in addition, he is interested in preternatural powers, complex technology and its uses, was well as exploring social issues.

Like many mangaka, Ōtomo started out by creating short works. *Domu*, started in 1980, marked his first major work, an unsettling story of child telekinesis, set in an apartment complex. The artwork is dense and dark and the depictions of the architecture highly detailed, conveying a sense of realism amidst the science-fiction. Ōtomo's first break into anime was as a character designer on Rintarō's *Harmagedon*. The following year he started work developing the manga *Akira* (1982–90), a lengthy epic which embraced multiple themes with its science-fiction examination of an apocalyptic future. In 1988 Ōtomo was given the opportunity to develop an anime from this still unfinished work. The result was a heady mixture of action and Armageddon, made all the more impressive by the realistically proportioned characters, detailed depictions of a future Tokyo and incredibly high production values. Rich and complex and by no means an easy watch, it referenced the horrors of the past (nuclear explosion) and issues of the present (youth biker gangs) intermingled with distrust of governmental authorities that said as much about contemporary society as the future dystopia it sought to depict.

Ōtomo's strong sense of creativity has also led him into screenwriting and design. Familiar themes could be found in *Rōjin Z* (1991), which addresses the issues of caring for an ageing population. The premise revolves around a society where technology has developed to the extent that robot beds can take care of all the needs of the elderly, but this apparently innocent invention leads to significant and shocking consequences. Ōtomo also wrote the screenplay for *Metropolis* (2001), which similarly explored the role of technology and robots within society.

Ōtomo returned to directing as one of the contributors to the anthology anime *Memories* (1995), which he also wrote. The three episodes that comprise the film have very different stories and styles but are linked by a central theme concerning the conflicts between humanity and technology. Ōtomo directed the final segment, *Cannon Fodder*, set in an alternative twentieth century at war, which shows us family participation as a father and son

take part in the war effort; the son dreaming of being a soldier and the father preparing cannon to be fired at the anonymous enemy. It's a bleak premise and the design is similarly sombre, although elements of the technology, notably the steam machinery, would work their way into his future animations.

Steamboy (2004) was a lengthy production and arguably the most expensive anime ever produced. It was a family friendly, *Boy's Own* style adventure set in an alternative Victorian England which allowed Ōtomo's creativity and imagination quite literally to run riot.

Never one to specialise in just one medium, Ōtomo has also made live-action films, directing *World Apartment Horror* (1991), which involved yakuza and evil spirits, as well as the insect-based *Mushishi* (2007). A lifelong cinephile, Ōtomo's work combines intelligent and perceptive plots with incredibly detailed and high-quality production values. His artistry and technical ability create gripping stories that often ask more questions than they answer and this makes his output ripe for analysis.

ANNO HIDEAKI (b 1960)

A combination of elements make the work of Anno Hideaki so interesting – he is not only an artist and animator but also a director of some live-action films. His success lies with his knowledge and love of anime's history and his clear understanding of genre alongside his ability to integrate philosophical and religious themes, combining these with fascinating characters and action-based narrative constructions that encompass everything from comedy to romance to emotional devastation. Elements from seemingly incompatible genres collide with self-referential themes to produce something that goes beyond mere entertainment to mix social 'coolness' with intellectual appropriation that, at times, has to balance mainstream popularity with confrontational existentialism.

Anno started out as an animator while attending Ōsaka University of Arts. It was his appreciation of anime that led him to become involved with creating a fan-based animation alongside fellow

students for fan conventions – Daicon III and IV – which eventually led to him being expelled. He was involved with animation work on *Macross* before responding to a call for animators from the studio who were producing Miyazaki's *Nausicaä of the Valley of the Wind*. He was taken on and worked on animating the impressive God Warrior for the film that would ultimately result in the creation of Studio Ghibli. Anno would maintain his links with the studio over the years.

The films he created for Daicon led Anno and his fellow animators to establish Studio Gainax, although Anno's relationship with the studio he helped found would vary. He had a number of roles on the various projects, from his animation work on *The Wings of Honnêamise*, to his directorial debut on the OVA *Gunbuster* (1988), a densely constructed multi-genre science-fiction series featuring alien monsters, giant mecha and even sport. *The Secret of Blue Water* (1990) was based on Miyazaki's concept of Jules Verne's works (notably *20,000 Leagues Under the Sea*) and adapted into a series that recalled some of the more renowned 1970s World Masterpiece Theater anime, with its historical, science-fantasy-adventure tale. Anno's next work would become one of the most highly acclaimed and controversial anime series of all time, *Neon Genesis Evangelion*, an enthralling combination of apocalyptic science-fiction coupled with drama, relationships, giant robot machinery and peril, as well as emotionally challenging personal situations. Its enormous popularity, coupled with general confusion and misunderstanding of the work, especially surrounding its ending, resulted in the series being re-imagined, initially in two feature-length re-interpretations – *Evangelion: Death and Rebirth* (1997) and *The End of Evangelion* (1997).

Anno also began experimenting with live-action films. After *Love & Pop* (1998) he directed *Ritual* (*Shiki-Jitsu* [2000]) for Studio Kajino (a Ghibli subsidiary), an adaptation of Fujitani Ayako's novel about a relationship between a director and a girl he keeps encountering. This film relates to the emotional and creative concerns of an artist and contrasts sharply with *Cutie Honey* (2004), a deliriously over-the-top live-action fantasy, in many ways a far more tasteful but

no less camp adaptation of Nagai Gō's 1970s manga, where the titular character is a superheroine with maximum skills and minimal costume. It's as close to anime as live-action cinema can get.

In 2006 Anno established Studio Khara. In partnership with Gainax, he returned to work on a new series of *Evangelion* films. *Rebuild of Evangelion* is a tetralogy: *Evangelion: 1.0 You Are (Not) Alone* (2007), *Evangelion: 2.0 You Can (Not) Advance* (2009), *Evangelion: 3.0 You Can (Not) Redo* (2012) and *Evangelion: Final* (2013), which retained some elements of the original and enhanced others, embellishing and expanding the story.

KON SATOSHI (1963–2010)

Kon Satoshi's work is striking, complex, intelligent and provocative. Former mangaka Kon creates densely imagined multi-media environments and then dissects and discusses them. Many of his themes are connected with the characters' perception of reality which, in turn, links with the viewer's relationship to the events in the narrative. Kon's approach to narrative construction is often non-linear, creating a psychological puzzle that has to be pieced together in order to understand its meaning. Even when his stories have linear narratives, they still question the protagonists' perceptions of their lives. Not just an animator, Kon was also heavily involved with writing and designing his films, which meant that his works are imbued with a unique vision.

Having enjoyed watching anime throughout his youth, Kon had wanted to become an animator from an early age and became a mangaka while studying at college, creating manga for Young Magazine which was, at the time, serialising Ōtomo Katsuhiro's *Akira* manga. Kon found a job as an assistant to Ōtomo and worked on *Rōjin Z* as an animator. He also contributed to *Patlabor 2* and wrote the screenplay for *Magnetic Rose*, the first short in Ōtomo's portmanteau film *Memories*.

Kon's debut *Perfect Blue* (1997) is a distorted thriller, based on the novel by Takeuchi Yoshikazu (although the source material was

adapted quite significantly), about a former pop idol launching a new career as an actress but struggling to differentiate fantasy from reality and becoming increasingly paranoid. These themes would recur in many of Kon's subsequent films. In *Millennium Actress* (2001) Kon plays with time, deconstructing the barriers between past and present, as we learn about the life of a 70-year-old actress through a camera crew documenting her fascinating career. Kon's most conventional film is the bittersweet *Tokyo Godfathers* (2003), a story about three homeless people looking after an abandoned baby in the run up to New Year's Eve.

Paranoia Agent (2004) was Kon's only TV series. He claimed that so many ideas had had to be omitted from his first three feature films, it would have been wasteful to have discarded them. The episodic nature of the resulting series, which is glued together by an overall story arc and thoroughly menacing antagonist, meant that Kon could exploit all these ideas and themes to produce an absorbing and occasionally terrifying series.

Paprika (2006), based on the novel by the deliciously capricious author Tsutsui Yasutaka, is a whirlwind of imagination and a riot of colour. The prototype for a dream machine that allows people to enter and record other people's dreams for psychological therapy purposes has been stolen by a 'dream terrorist' who starts invading the consciousness of previous users. Kon's stunning use of animation and raucous soundtrack reflect his stream-of-consciousness approach to the subject matter as reality and dreams become increasingly warped. Ideas about perception and reality are key themes within Kon's work, and not only for the characters. In *Paprika* Kon constantly challenges the audience's perception of plot and protagonist, as he draws us into this captivating and frightening world.

Sadly, Kon had started work on his new feature *The Dream Machine* (*Yume Miru Kikai*) when he was diagnosed with terminal pancreatic cancer. He passed away in August 2010, aged just 46. At the time of writing, *The Dream Machine* is due to be released posthumously. Kon's legacy can be found in the curious blend of entertaining narratives that ask deep psychological questions

but which are also engaging, intelligent, thought-provoking and occasionally confrontational.

WATANABE SHINICHIRŌ (b 1965)

With jazz space cowboys and hip-hop samurai amongst his protagonists, Watanabe Shinichirō is probably amongst anime's coolest directors. While most animators are primarily concerned with the visual elements of their films, music is an important inspiration for Watanabe, not only fundamental to his stories but also the style he wants to convey. His anime combine many aspects of Western and Japanese culture, often elements that shouldn't complement each other or would seem anachronistic, and somehow he blends these to create worlds that are fascinating and original.

Watanabe started out with Sunrise Studios. Initially involved with storyboard design and episode direction for TV series such as *Obatarian* (1990) and *Mobile Suit Gundam 0083: Stardust Memory* (1991), his first directing opportunity came when he was offered the chance to take the helm (alongside Kawamori Shōji) on *Macross Plus* (1994), a four-episode OVA that followed on from the apocalyptic mecha sci-fi series, *Macross* (1982).

Cowboy Bebop was Watanabe's first TV anime as director. Less of a space opera and more of a space jazzfest, it told the story of bounty hunter Spike Spiegel and an assortment of associates traversing the solar system in search of bounty and trying to avoid the authorities. A follow-on film, *Knocking on Heaven's Door*, was released in 2001, featuring Spike and the gang seeking to find a terrorist who is about to set off a dangerous pathogen on Mars. Naturally, large quantities of hard currency are on offer if they succeed.

Samurai Champloo (2004) was Watanabe's next major work. Set in the eighteenth century it tells the story of a couple of swordsmen reprobates, the hot-headed Mugen and laid-back rōnin (masterless samurai) Jin, who join forces with a teenage girl, Fuu, who seeks to find a samurai smelling of sunflowers. Together they wander across Japan encountering various characters along the way. With more of

a purpose to the narrative than the ultra laid-back *Cowboy Bebop*, *Samurai Champloo* has a postmodern outlook that is deliberately, and enjoyably, anachronistic; but even with breakdancing swordplay this does not detract from the fact that the whole is very respectful of Japanese culture and incorporates elements of Western culture as well. Chanbara (sword fighting), ukiyo-e, kabuki, onsen (hot springs) and Shintō shrines are all part of the experience, as are the beautifully recreated Edo settings, even if they are occasionally daubed with graffiti.

Watanabe went on to pursue his musical interests, producing the music for *Mind Game* and *Michiko to Hatchin* (2008), the latter of which takes place in an alternative Latin America and features the music of the Brazilian, Alexandre Kassin, a musician known for mixing styles – notably psychedelic, funky samba.

After a brief slot directing the segment *Baby Blue* from the anthology *Genius Party* (2008), Watanabe returned to directing TV anime with *Kids on the Slope* (*Sakamichi no Apollon* [2012]), adapted from Kodama Yuki's manga. It is easy to see how the plot appealed to the director: conscientious high-school student Kaoru has to move schools as a result of his family's work commitments. He's always been introverted and a bit prissy, but then he meets school rebel Sentarō and is introduced to the joys of jazz. Being a pianist, it's not long before he's joined a band and found some friends.

At the time of writing Watanabe is involved with a live-action version of *Cowboy Bebop*. He has stated that the 'Champloo' in 'Samurai Champloo' comes from an Okinawan term 'chanpuru' which means 'something mixed'.[9] This perfectly sums up his approach to realising his vision. He is a fascinating director who blends cultural elements from all over the globe to create a glorious conglomeration of cool.

SHINKAI MAKOTO (b 1973)

Shinkai Makoto has been hailed as the new Miyazaki Hayao. Whilst this modest animator has played down such comparisons, it is

easy to see why they would be made, because his style is highly distinctive and his animation technique meticulous in execution. His films are genuinely beautiful and occasionally ethereal. His mise-en-scene is incredibly detailed and his use of light and shadow quite remarkable. What sets the design apart is the attention to detail in even the most banal of settings – ordinary towns with their electricity wires and railway crossings. When his narratives take a turn for the fantastical, they do so in a way that is seamless because you are utterly immersed in his world.

The nature of friendships and relationships lie at the heart of his films, from a cat's adoration of his owner, to the love triangle of *The Place Promised in Our Early Days*, and the 'will they-won't they' story of *5 Centimeters Per Second*. Time and distance are important themes and Shinkai explores how friendships can become closer or drift apart. Sometimes he adds a science-fiction context, whilst other stories are firmly grounded in reality. His narrative structures are often unconventional, exploring the microcosms of a relationship, often within a much broader context. Dreams and visions are also important elements within his work.

After graduating in Japanese literature from Chūō University, Shinkai worked as a graphics designer for a video-game company. He produced his first film, *She and Her Cat*, in 1999, writing, directing and providing the voice of the eponymous feline. Running at just under five minutes, this black-and-white short follows a year in the life of a cat who lives in an apartment with his owner, a young woman. Simple, underplayed and just a little maudlin, it won many awards. His next film was to be the 25-minute OVA, *Voices of a Distant Star* (*Hoshi no Koe* [2002]). It is a remarkable work, especially considering that Shinkai wrote, produced and animated it on his personal computer. He and his wife even provided the original voices for the characters. Inspired by the image of a girl in a cockpit using her mobile phone, the short follows the communications between schoolgirl Mikako, who becomes a mecha pilot in order to participate in an alien war, and her school friend Noburu. Mikako's unit is attached to a spaceship which is travelling into deep space.

The further she travels, the longer it takes for her messages to reach her friend. More than anything, she wants to tell him that she loves him. Blending action with a romantic drama, the finished product is wistful and strangely uplifting.

Shinkai's first feature film was *The Place Promised in Our Early Days* (2004). Instead of predominantly working alone, this was a full-scale production. Set in an alternative Aomori (a province in Northern Japan) it follows the story of three school friends who vow to visit a mysterious tower. *5 Centimeters per Second* (2007) returned to the real world. A film of an hour's length, each of its three segments follows particular events in the life of Tōno Takaki and his elementary school friend Shinohara Akari. With an unusual structure, just glimpsing into moments of their lives, this is a meditation on relationships and how they are affected by time and distance.

Shinkai's latest feature is his most ambitious yet. Coming in a shade short of two hours, *Children Who Chase Lost Voices* (*Hoshi o Ou Kodomo* [2011]), aka *Journey to Argatha*, is a coming-of-age story that mixes adventure and romance in a fantasy setting. Its major theme is that of coming to terms with death, as a young girl embarks on a journey into the realm of the underworld, Argartha, but it's not all morbid. There are lively and exciting scenes as well as moments of introspection. And, of course, both worlds are beautifully realised.

Shinkai Makoto is not the new Miyazaki. But he is an animator whose films are brilliantly designed and can spark a similar sense of wonder for audiences.

A SELECTION OF ANIME

As you can no doubt surmise, a book of this size is simply not large enough to cover every anime created or even a comprehensive selection of the best. We would have similar problems if we were writing a book about any cinema genre. We have thought long and hard about what to include (and, even more difficult, what to exclude) within this section and have tried to offer a selection of films that covers as many different genres, styles and markets as possible. This means that, with great reluctance, some fantastic animations have had to be omitted. We would have loved to have covered every Studio Ghibli film and every Kon Satoshi film in detail, for example, but simply do not have the space (please do see every Studio Ghibli and Kon Satoshi film because they are emphatically worth watching), and we wanted to provide as diverse a range of anime from across its history as we could.

Momotarō the Undefeated (Nihon-ichi Momotarō [1928]*)*

Directed by: Yamamoto Sanae
11 mins

An elderly couple are overjoyed when the wife brings home a giant peach that has washed down the river and discovers a young boy inside. He is Momotarō, and he is a 'kind-hearted, mighty boy' who grows into a 'gallant young man'. He defeats a local demon

then teams up with a monkey, a dog and a pheasant to travel to Demon Island and challenge all who reside there. He returns home triumphant, bearing treasures.

Momotarō is based on a traditional Japanese folk legend and has appeared in anime right from its inception, from his first starring role in Kitayama Seitaro's 1918 film. The basic style for Yamamoto's charming version is very much tableau-based, with the action taking place in front of static backgrounds. Although the animation is generally very restricted to one plane (left to right and vice versa), the quality of the movement and the timing of the fights demonstrates a sophisticated perception of the animation process. The character design is very detailed, most notably in the costumes of the lead characters; Momotarō himself wears traditional dress that is also convenient for fighting.

Momotarō would go on to have further adventures with his chums in Murata Yasuji's *Aerial Momotarō*, where our hero takes on an eagle, and *Momotarō's Underwater Adventure*, where he is called upon to defeat a vicious shark that has been attacking submarines, as well as his wartime excursions with *Momotarō's Sea Eagles* and *Momotarō's Divine Sea Warriors*. A TV series in 1989 updated the character for a new generation, even sending him into space. Momotarō would appear in many future anime, right up to a pastiche *My Neighbours The Yamadas*.

The Tale of the White Serpent (Hakujaden [1958]*)*

Directed by: Yabushita Taiji, Okabe Kazuhiko
Feature film, 78 mins

Tōei Studios were fundamental to the development of animation within Japan. Crucially, they established the two major markets for their animated products – that of television and feature-length film. *The Tale of the White Serpent* was the first colour, feature-length animation to be produced in Japan.

Set in China, this is a love story between the beautiful princess Bai-Niang and young man Xu-Xian. Xu-Xian had known Bai-Niang

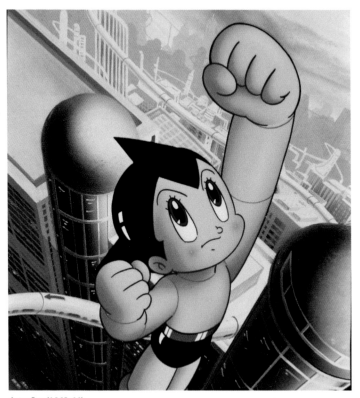

Astro Boy (1963-66)

Space Battleship Yamato (1974)

Galaxy Express 999 (1979)

Urusei Yatsura (1981-86)

Cowboy Bebop (1998)

Fruits Basket (2001)

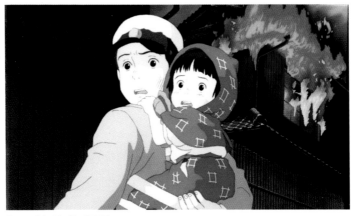

Grave of the Fireflies (1988)

Chobits (2002)

Wolf's Rain (2003)

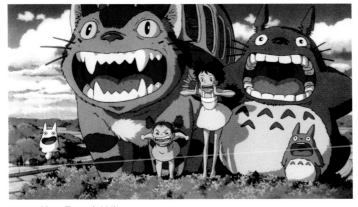

My Neighbour Totoro (1988)

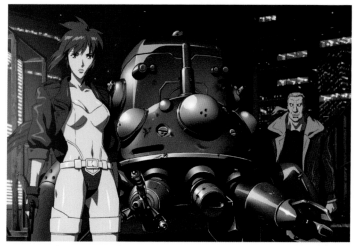

Ghost in the Shell (1995)

Whisper of the Heart (1995)

Elfen Lied (2004)

Ouran High-school Host Club (2006)

Metropolis (2001)

Pom poko (1994)

Spirited Away (2001)

The Place Promised in Our Early Days (2004)

Final Fantasy VII: Advent Children (2005)

xxxHolic (2006)

Strawberry Panic (2006)

The Sky Crawlers (2008)

Jin-Roh: The Wolf Brigade (1999)

5 Centimeters Per Second (2007)

Royal Space Force: The Wings of Honnêamise (1987)

Summer Wars (2009)

Death Note (2006)

Fullmetal Alchemist: Brotherhood (2009-10)

since he was a child, but she was very different then. Bai-Niang was actually a white snake, who had been Xu-Xian's friend. But, after casting aside her reptilian form, the monk Fa-Hai recognises that she is a spirit and separates the pair. Xu-Xian seeks any way he can to find his serpentine amour. Fortunately he has help in the guise of his companions, Panda and Mimi. Bai-Niang has her own assistance, from Xiao-Xin, also a magical creature who has transformed from a fish. But these are harsh times for all creatures as there is magic in the air, dangerous waters to traverse and criminal syndicates to confront if true love has any chance of blossoming.

The quality of the animation on *The Tale of the White Serpent* remains impressive despite its age, and the character design within its fantasy scenario makes for a timeless tale that mixes romance with cute supporting characters. Despite being released over a dozen years before the massive public panda craze that also created a success for Takahata's *Panda ko panda* (1972), *The Panda and the Magic Serpent*, to give this film its American title, suggests that there is a role for the panda that gives the film (in some edits) a more family-centred feel. The fantastical, spiritual and romantic elements are complemented by an amusing buddy relationship between the animals, especially Mimi and Panda, who are also involved in the action and conflict, whether that be from the magical world or the animal world – notably a pig-led crime syndicate.

The Tale of the White Serpent is an excellent introduction to the world of modern animated feature films and created a viable industry, defining Tōei as a studio which could create solid commercial animated cinema. It was the first anime to be distributed in the USA.

Astro Boy (Tetsuwan Atomu [1963–6])

Directed by: Tezuka Osamu
TV anime, 193 episodes

Mushi Productions was formed by Tezuka Osamu in the early 1960s and *Astro Boy*, based on the star character from his 1950s manga, was its first TV production. It holds an important place in

both the history of anime and its heart, and the animation, amongst the earliest to be distributed overseas, remains exemplary even by today's standards.

The early twenty-first century has advanced technologically to the extent that robots are a part of everyday life, there to assist humans with even the most menial of tasks. Talented scientist Dr Tenma is devastated when his boy Tobio tragically dies in an accident involving an automobile. But while the good Dr Tenma cannot directly resurrect his deceased son he can create a robot with an uncanny resemblance to him. The new robot looks like Tobio but is not Tobio, and the realisation that this 'boy' will never grow up causes further distress for his creator. Too late to recognise that the little robot with amazing superpowers is, in fact, capable of understanding and experiencing human emotion, Dr Tenma sells the robot to an evil circus owner. But Astro Boy is rescued by the Ministry of Science's Professor Ochanomizu and uses his prodigious powers to fight evil.

Astro Boy is one of the most iconic characters created and yet his design was deliberately kept simple: clean lines, simple costuming, distinctive hair and large eyes to convey emotion. The series depicts impressively designed futuristic cities which feel realistic (this series was made well before Japan achieved its international reputation for technological achievements) with a plethora of robots ranging from chibi to gigantic. The human character design ranges from normal depictions to verging on cartoon comic with notable extreme hairstyles, exaggerated expressions and choreographed movements that add elements of fantasy or comedy to the proceedings.

Tezuka's great skill was telling fantastic stories about very human characters. The interaction between humanity and machinery was a theme that would become prevalent in many future anime. Films such as *Metropolis* (based on a concept by Tezuka) and *Ghost in the Shell* ask complex questions about artificial intelligence and what it is to be human. *Astro Boy* appears, at least on the surface, to be more simplistic, but, despite his apparent indestructibility as a boy hero, the little robot does have human emotions, including moments of

worry and disappointment, and he frequently asks questions about issues of morality – what is right and what is wrong – in between the hugely enjoyable moments of combat and flying. Probably the most influential science fiction and fantasy anime created, *Astro Boy*'s onscreen adventures are constantly enjoyable and engaging.

Jungle Emperor (Jungle Taitei [1965–66]*)* aka *Kimba The White Lion*

Directed by: Yamamoto Eiichi
TV anime, 52 episodes

Leo is a white lion who has had a rough start in life. His father, Panja, king of the jungle, was killed by hunters and his pregnant mother captured, bound for a zoo. Leo was born in captivity on a ship but escaped by leaping overboard and made his way back to Africa. He tries to live by his father's values, ensuring that both animals and humans can live in peace together. Eventually, in future series, he marries Lya and has two cubs, Lune and Lukio, who are raised to continue his ideals.

Based on Tezuka's manga from the 1950s, *Jungle Emperor* was the first colour TV anime to be released in Japan. The series was syndicated to the US just a year later, marketed as *Kimba The White Lion*, and proved to be a huge hit. What is interesting is the way that Leo interacts not only with the other creatures of the jungle – having to ensure a consensus amongst the animals and dealing with rivals, especially his lion nemesis, Claw – but also the way that he communicates with humans as well. These result in confrontations with poachers and hunters but also co-operation with the wildlife rangers. Indeed, the series doesn't balk at the depiction of some of these skirmishes and the violence is surprisingly graphic. There is also a significant amount of character death. However, the whole is based around Tezuka's primary premise of showing how different species should try to live together in harmony and peace.

Tezuka's design for his lead character is again notable for its simplicity – Leo has Astro Boy's wide, expressive eyes and

distinctive shock of a mane perched atop his cute head. Tezuka claimed that he had originally intended Leo's colouring to be yellow. Apparently he had been working late in poor light and, when he returned to review his work the following morning, noticed that the fur colouring had remained white.

It has been noted that Leo/Kimba bears an uncanny resemblance to Disney's *The Lion King* (1994) and it is easy to see the similarities: the death of the father, the range of supporting characters, the quest to achieve peace, some of the character design, and even the lead character's name, Simba. However, the studio insisted that this was pure co-incidence.

Sazae-san (1969–present)

TV anime, > 6,000 episodes

Recently there was an announcement that *The Simpsons* had surpassed *The Flintstones* as the longest-running American animated television series. Without denigrating the accomplishment of that long-term broadcasting achievement, there is an anime that exceeds its longevity with ease.

Sazae-san is a Japanese institution, which started out as a popular *yonkoma manga* by Hasegawa Machiko in 1946. In 1949 *Sazae-san* went national in the *Asahi Shimbun*, one of Japan's top broadsheets, where it was published daily for the next quarter of a century. The comic was transformed into a TV anime series in 1969 and has maintained its regular broadcast every Sunday evening since then. *Sazae-san* is essentially a series of humorous vignettes about family life. Although the comics were quite radical at the time, the anime is a gentler affair, grounded in traditional values and viewed with affection by Japanese audiences. Sazae-san is a housewife who lives with her parents and siblings, as well as her salaryman husband and their child. The series' success lies with its wholesomeness – its lack of conflict and general niceness; the kids occasionally get into minor scrapes and there is some mild

slapstick but this is a Japan depicted as the Japanese like to see it – harmonious and community-based.

Sazae-san is not only old-fashioned in its outlook, it was also one of the last anime to be made using traditional cel animation, long after the use of CGI had become the norm in TV anime, with its gruelling production schedules. And it always ends with a janken (paper-scissors-stone) contest between Sazae-san and the audience.

Doraemon (1973, 1979, 2005)

TV anime

Nobi Nobita has a rather special friend. It's a cat, Doraemon, who hails from the future, way in the twenty-second century, and has travelled back in time to use his super technologically advanced capabilities to aid Nobita whenever he needs him. For Doraemon knows that he must save Nobita from an otherwise awful future thanks to the boy's general incompetence. He's terrible at sports (something that Doraemon, we discover, is not), he dislikes school and his mother is constantly moaning at him about not cleaning his bedroom or, even worse, not doing his homework, something Nobita really should get on with because his academic record is distinctly unremarkable. Having Doraemon as a companion is undeniably cool – he has a magical pouch in his tummy that contains multifarious goodies and a propeller on his head for flying, but Doraemon is not a slave to Nobita's endless needs and, knowing his potential future, is as demanding as Nobita's mother, albeit technologically far more impressive. However, his assistance often leads to further trouble and much gentle amusement all round.

Originally created as a manga in 1969 by the writers known as Fujiko Fujio (Fujimoto Hiroshi and Motoo Akbiko), *Doraemon* later became an anime that is still running and remains popular to this day. Predominantly aimed at a children's market (although an older demographic than educational anime such as *Anpanman* or *Shima Shima Tora no Shimajirō*), *Doraemon*'s plot and characterisation

actually appeal to a wider age group than its target audience. As well as the television anime, there are also regular cinematic releases which always have a significant impact on the box office, so the franchise, with its plethora of tie-in products, is both popular and financially successful. After a very brief anime series released in 1973, *Doraemon* became a huge televisual hit. Doraemon is the ideal companion to Nobita in so many ways. Beyond the inevitable thrill of having a pet (which he isn't, he's a helper and companion), there's the added wonder of his being equipped not only with a multitude of abilities but also awesome futuristic gadgetry.

Companionship and humour are coupled with enjoyable, simplistic plotting and occasional science-fiction themes, and Doraemon, whose features are distinctly circular, making him half minimalist painting, half huggable big-headed cat, is an ideal introduction to anime because of his instantly recognisable characterisation and the sheer joie de vivre of the story.

Space Battleship Yamato (Uchū Senkan Yamato [1974]*)* aka *Star Blazers*

Co-directed/co-written by: Matsumoto Leiji
TV anime, 26 episodes

An epic science-fiction story with a future planet Earth on the brink of being obliterated if a group of heroes don't succeed in their goal, *Space Battleship Yamato* combines character drama with a space adventure to create a hugely influential TV series.

Armageddon seems inevitable for the earth. The process has already begun in an attack of radioactive bombs launched with apparent inevitability by the alien Gamila, led by their ruler Desslar. In one year's time, the Earth will be destroyed by the radiation caused by the bombs, which have already caused immeasurable damage and reduced the world's oceans to desiccated husks, resulting in what remains of the human population being forced to live underground. Interplanetary revenge would be one option,

but that is unfeasible. Fortunately, Queen Starsha, from the distant planet Iscandar, is willing to offer aid via the Cosmo-Cleaner D machine (a device that will cleanse the radiation) and provides a wave motion engine that enables faster-than-light-speed travel so that humankind can traverse the galaxy to fetch it. A spaceship needs to be built in double-quick time and the dusty oceans have revealed the remains of the ancient Battleship Yamato, which can be adapted for such a journey. Onboard the Yamato, Captain Okita builds his crew of professionals: mechanics, pilots and soldiers who will have to bond as a team on a journey that will take them far from home. They need to locate the machine that will save the earth and return it home safely, knowing that the evil Gamila will attempt to thwart their every move.

Although many elements of *Space Battleship Yamato* seem familiar these days and have now become staples of the spaceship drama, the series was quite revolutionary for the time. Reminiscent of *Star Trek* (1966–) with its identifiable crew members and individualistic story elements *Space Battleship Yamato* also had an overriding story arc. It is Matsumoto Leiji's design and characterisation that makes this series stand out as an intelligent drama. Additionally, the character design was more realistic than typical anime styles of the time with fewer exaggerated features (although the female character sports typically Matsumoto eyelashes). From the very opening we see the leadership challenges that Captain Okita has to face – his crew will need to demonstrate honour, integrity and loyalty as well as courage if they are to succeed in their mission. The tension in many of the battle scenes is palpable. The spaceships are designed and animated with loving attention to detail; many of them were based on actual military vehicles but adapted for space.

The series was released in the USA as *Star Blazers* and proved to be popular. In Japan, a sequel series was made in 1979 and it has been resurrected in various forms and spin-offs since, including a live-action film in 2010.

Dōjōji Temple (Dōjōji [1976]*)*

Directed/written by: Kawamoto Kihachirō
Short film, 19 mins

Although the anime format is typified by methods that involve the process of drawing images onto cels, the films of Kawamoto Kihachirō demonstrate a rich variety of alternative techniques for the format. These include stop-motion, photo-montage and puppet animation, sometimes a combination of all three, which give his films an inimitable style.

Dōjōji Temple is a short film created by one of Japan's most artistic and distinctive animators. It is a film steeped in traditional style with its wonderful depiction of a fantastical mythological story about an evil spirit – spooky horror that mixes Japanese artistic traditions with avant-garde sensibilities. Two pilgrims, intending to visit a temple, spend a night at an inn. The younger is approached by a beautiful woman, but he rejects her advances. Shunned, she turns into a demon and then a dragon and pursues her quarry to the Dōjōji temple, where he is given sanctuary. And hell hath no fury like a demon spurned.

The oni (demon) plays a strong part in Japanese mythology and often appears in traditional stories and plays. Demons are common creatures in Japanese horror films, notably such classics as Shindō Kaneto's live action *Onibaba* (1964), and they also appear in other Kawamoto animated shorts, including the more obviously titled *Oni* (1972). What's notable about *Dōjōji Temple*'s macabre little tale is the way that Kawamoto embraces traditional Japanese art forms in two very distinct ways. Firstly, he animates puppets, bringing together the traditions of bunraku with the theatrical gestures of Noh, giving 'life' to the inanimate, a difficult thing to achieve, particularly bearing in mind the lack of expressions available on the puppets' carved faces. Secondly, the mise-en-scene is imbued with the legacy of ukiyo-e. When the demon transforms into a dragon, she swims across the river, which is depicted as having the wonderful fractal

waves as seen in so many woodblock prints. The backgrounds look as though they have come straight from ukiyo-e, utterly flat, even as the 3D puppets roam across them. The quality of the animation is remarkable (the wind flowing through the demon woman's hair is astonishing for its dynamism) thanks to Kawamoto's meticulous approach to his art.

Kawamoto's love of the macabre and surreal can largely be attributed to the fact that he trained as an animator with Czech master Jiri Trnka in the 1960s. Trnka's influence is manifold; like Kawamoto, Trnka evolved his artistic emphasis from puppetry to animation with similar accentuated wonder of tradition and technique that produced works ranging from fairytale mythology in *Old Czech Legends* (1953) to political art films such as *The Hand* (*Ruka* [1965]). Kawamoto's work therefore is a wonderful combination of European art-house and Japanese aesthetic tradition.

Never tied to a particular style, but always imbued with his unique vision, Kawamoto's other animations include *The Poet's Life* (1974), based on a Kōbō Abe tale, telling a socialist story that features a mother who gets woven into a loom and transformed into a jacket. With a bleak, sepia setting, it's full of metaphor as the suppressed workers' hopes and dreams vaporise to form as clouds, only to fall back to earth as snow. *The Trip* (1973) opens with Chris Marker-esque stills and then takes us on a surrealist journey using cut-out animation that is part Salvador Dalí and part Terry Gilliam.

Galaxy Express 999 (Ginga Tetsudō Surī Nain [1979]*)*

Directed by: Rintarō
Feature film, 130 mins

Hoshino Tetsuro wants to embark upon 'a journey to the stars' in order to become partly mechanised, which means that he will live forever. But this process is awfully expensive, except in the Andromeda galaxy where it just happens to be free, and this means that Tetsuro needs to obtain a ticket on the Galaxy Express 999. Mechanisation

will also help him fulfil his aim to kill Count Mecha in order to avenge the death of his mother. Finding the Count's elusive Time Castle isn't going to be easy and the journey will need to be taken aboard the Galaxy Express whose scheduled timetable takes in a large number of stops throughout the cosmos. Aiding him on his quest is Maetel, a woman who looks rather like his deceased mother, and she manages to get the pair aboard the train. Their voyage takes them to a variety of planetary locations where they encounter new friends and foe, while constantly seeking a confrontation with the Count.

Galaxy Express 999 (pronounced 'three-nine') is a feature-film spin-off from the manga by Matsumoto Leiji and the television anime. The Galaxy Express is a steam train, at least in appearance, although this is purely a cosmetic choice, but it adds to the romance of the story. The strength of the film lies in its combination of ripping *Boy's Own* tale of discovery, action and adventure with an underlying discussion about the nature of humanity, along with some fun science (the length of a day on each planet determines the train's timetable) and pirates. A plethora of identifiable and quirky supporting characters add to the entertainment.

Matsumoto Leiji's concept for the film was very loosely derived from Miyazawa Kenji's novel *Night on the Galactic Railroad*, although he takes the story in a very different direction with its modern science-fiction theme. Engaging and entertaining anime, this mixes an exciting adventure story with serious questions about humanity and technology. The closing title song remains a popular anime tune, even if only for those of a certain generation…

Mobile Suit Gundam (Kidō Senshi Gandamu [1979–80])

Directed by: Yoshiyuki Tomino
TV anime, 43 episodes (original series)

Mobile Suit Gundam marks the start of one of anime's longest-running franchises, often described as one of the defining mecha anime. Mecha, effectively a form of giant armour, are robots piloted by humans.

Zeon has rebelled against the Earth and its democratic Federation, and that means only one thing: war. This is a civil war that has seen conflict both on Earth and its territories in space, resulting in much destruction and death. When the Federation's warship, the White Base, arrives at a colony to collect a prototype weapon, it is attacked by Zeon forces. But plucky civilian teenager Amuro Ray chances upon the Federation's mecha, the Gundam, a mobile mechanical suit, and manages to pilot it to defeat the Zeon aggressors, giving the remaining crew and colony refugees a means of escape. Little does he realise that he is about to be drawn into a lengthy and brutal war...

To be honest, *Mobile Suit Gundam* takes a while to get into. At the start of the series, the plot is confusing, the characters indistinct and the animation virtually static. However, it is worth sticking with it, because what eventually emerges is a much more complex series than is initially presented. Of course there is a large amount of exciting battle action, but this is balanced with scenes of introspection and angst as well as political themes that develop as the plot progresses.

As a viewer you are naturally inclined to side with the preordained heroes but, like a lot of anime that features conflict, the character motivations are not reduced to overtly simplistic 'good' and 'bad'. Thus the enemies of the series are depicted, occasionally, as having feelings and showing compassion. Similarly, the gender-bias of army conflict shuns expectations by depicting notably strong female characters (even if they can't drive very well), despite this ostensibly being marketed as a boys' show. The female characters are given the opportunity to discuss their position in the scheme of things and their role beyond that of gender-specific minor characters. These aspects help the series develop beyond a simplistic drama – so there is also the cute gourd character that is basically fun, as well as very young children who spout inappropriate comments or lark about to lighten the tone.

As easy as it is to examine the commercial behemoth that Gundam has become, with the enthusiasm for mecha-based entertainment and gaming offshoots continuing to this day, there is little doubt how important and influential the series was: elements can be seen in

Transformers as well as the technology and teenage characterisation depicted in *Neon Genesis Evangelion* and *The Wings of Honnêamise*, which also treated their narratives and their protagonists seriously.

Ashita no Joe (1980) aka *Tomorrow's Joe*

Directed/written by: Dezaki Osamu
Feature film, 152 mins

Sports anime is a sub-genre that has had an enduring popularity over the years and boxing provides a premise that's ideal for a dramatic narrative and plenty of action. *Ashita no Joe* incorporates a number of social issues within its themes as we follow the story of a tough hero who is determined to succeed in a tough world.

Joe is a delinquent ruffian with an outrageous quiff. He's had a poor start in life, having run away from an orphanage, and has generally learned to resolve conflicts using his fists. His natural fighting skills have caught the eye of former trainer Danbei, but his hot-headed attitude lands him in prison. Danbei sends him postcards instructing him in the art of boxing. Joe is then sent to a reform school where he and his chum Nishi meet Rikishi, an ex-boxing legend. Joe and Rikishi become rivals and fight a match in prison. Although he loses, this gives Joe the motivation he needs to train harder and, when he finds himself in the real world once more, he is ready to start a career as a boxer, and one with undeniable skills in the ring.

Ashita no Joe started out as a manga by Kajiwara Ikki and Chiba Tetsuya in 1968 and was made into a TV anime in 1970. A movie edited from the original TV series a decade later updated viewers with Joe's story (which had completed its manga run in 1973) or introduced new viewers to his tale, which continued in a further TV anime and film (1980–1). *Ashita no Joe* is a terrific drama precisely because it doesn't pull its punches. Joe has had a troubled life but this isn't a simple tale of redemption – conflict, tension and tragedy are inevitable parts of his story. Joe represents the working-class hero, the underdog. In his attempt to move on from the negativity

that engulfed his earlier life, he seeks to become a respected member of the sporting world but, with his criminal past, he struggles to be accepted. His fate is never in tune with expectations of a standardised hero figure and is far more interesting as a result. The story is very much set in the real world and the design and animation reflect this, although some sequences are deliberately portrayed in a sketched-out style which has the effect of giving an almost documentary realist feel within the cel animation format. Its popularity led to a number of continuations of the story – a tale that fortunately didn't become sanctified in amiable niceness.

Sports anime have always been a popular sub-genre: *Tiger Mask* was a wrestling TV series, *Captain Tsubasa* (1983–86) a soccer drama, *Slam Dunk* (1993–96) told the tale of a high-school basketball team, and there are no prizes for guessing the subject matter of *Aim for the Ace!* (1973–74) or *Prince of Tennis* (2001–05).

Urusei Yatsura (1981–86)

Directed by: Oshii Mamoru, Yamazaki Kazuo
TV anime, 195 episodes

Horny teenager Moroboshi Ataru has been randomly selected via computer to take part in an intergalactic game of tag which, if he manages to grab the incredibly cute horns of his opponent, the curvaceous and busty Lum, will result in the Earth not being invaded by the Oni alien race. Fortunately, this lecherous high-school kid, who already has a long-suffering girlfriend in the shape of Shinobu, wins the game by stealing Lum's tiger-print bikini top. The cad. Unfortunately, due to a misunderstanding, Lum seems to think that Ataru wants to marry her, something that Shinobu is none too happy about.

Urusei Yatsura roughly translates as 'Those Obnoxious Aliens' but it really is as far from obnoxious as it's possible to get. Based on Takahashi Rumiko's manga, it's a delightfully quirky comedy that typifies much of her work. Oshii Mamoru directed the TV series as

well as the first feature-film spin-offs. It's often stated that the art of comedy lies in the timing, and what is notable about this animation is that the timing of the gags is impeccable, especially considering that this is a (relatively) cheaply produced TV anime. You want to feel sorry for Ataru but it's just impossible – he really is completely hopeless. His mother frequently regrets having given birth to him, while his father valiantly ignores his son's latest indiscretion, steadfastly concentrating on reading his newspaper. Still, Lum – who yells 'Daaarling' at her husband at every opportunity and gives him an electric shock every time he misbehaves – as well as poor Shinobu, are there to keep Ataru in check. And then there's Lum's cute cousin, Ten, who immediately recognises Ataru for the flirtatious lech that he is and makes it his mission to irritate him as much as possible.

Takahashi's great talent lies in creating an offbeat premise, blending the ordinary with the unexpected, and throwing in some fantastic characters to make the whole something extraordinary. Her work is innovative, eccentric and, above all, very, very funny. Oshii has taken the source material and created a brilliantly realised anime. The series was enormously popular on its release and generated a series of OVAs with standalone stories that were similarly hilarious, running through the 1980s and into the 1990s.

Barefoot Gen (Hadashi no Gen [1983]*)*

Directed by: Masaki Mori
Feature film, 85 mins

Ever-exuberant Gen lives with his parents, older sister and younger brother. His mother is expecting a baby and Gen is rather hoping that his new sibling will be a boy. Life is pretty tough at the moment – Japan is at war and everyone is hungry. But, worse, Gen lives in Hiroshima. And on 6 August 1945 his world is changed forever when a B-29 bomber drops a nuclear bomb on the city, resulting in devastation and death. Gen loses his father and siblings. His mother

gives birth to a baby sister and Gen desperately tries to assist them both. But the horror of the bomb's aftermath becomes increasingly shocking: bodies piling up in the streets, the death toll rising, and the prospect of any decent future with his remaining family becoming increasingly slim for this young boy.

Although the character is fictional, *Barefoot Gen* is ostensibly based upon the experiences of author Nakazawa Keiji (who wrote the original manga), who was living in Hiroshima when the atomic bomb was dropped. Certain aspects of the bombing and its affects on the survivors still have political and social ramifications in Japan. In this deeply moving anime the horrors and actualities of the bombing are depicted in a way that is both heart-breaking and graphic, enhanced by the fact that the central character is a child, which makes the atrocity of the incident all the more upsetting. Indeed the anime addresses the personal experiences of the young and the emotional legacy of their situation, another example being found in Takahata's *Grave of the Fireflies*. *Barefoot Gen* depicts the horrific events in a way that is unrepentant but never seeks to sensationalise them. The shock comes from the details that Gen has to confront – the stench of death, the mass graves of the deceased, the maggots wriggling on decomposing flesh. There are so many issues that Gen has to deal with – from watching, helpless, as his father and siblings burn to death while trapped inside the family home, to getting a job caring for a cantankerous old codger in order to earn enough money to buy baby milk for his new sister. Perhaps the most moving scene occurs when his mother, whose milk has run dry, comes across another mother trying to breastfeed her dead child in a scene that is as profound as it is shocking. Both women are coming to terms with their maternal instincts and their losses, resulting in a situation which defies any kind of conceivable explanation.

What makes the watching of these horrific events bearable is Gen's indomitable spirit – the sheer optimism and determination of the character is uplifting, despite the misery and suffering he has to endure. The anime techniques range from almost abstract,

dreamlike colourisation to depictions of complete normality amidst the indescribable horrors, and this helps remove the film from either over-simplification or grotesque exploitation. The result is a film that is moving, informative and, above all, honest. A sequel, set three years after the original film, and also written by Nakazawa, was released in 1986.

Nausicaä of the Valley of the Wind (Kaze no tani no Naushika [1984]*)*

Directed by: Miyazaki Hayao
Feature film, 116 mins

One thousand years ago, the Earth became an uninhabitable wasteland of toxic filth, annihilated by the Warrior Giants. Isolated communities have now built up in areas that can maintain life and the tribe of the Valley of the Wind are trying to live sustainably in their rural hideaway. Nausicaä is the daughter of the Valley's King Jhil. An enthusiastic environmentalist, she is fascinated by the Ohmu, huge insects with armoured shells. When a Tolmekian warship containing the body of a Warrior Giant crashes into her village, she realises that this tribe plans to bring the ancient god to life. With the Tolmekians obliterating tribes that get in their way, Nausicaä must try to prevent the destruction of the Valley of the Wind and return the environment to as peaceful and stable a state as it can possibly maintain.

As with many of Miyazaki's stories, the major theme is that of environmentalism and humankind's relationship with the Earth. People have endured a thousand years of misery because of the pollution. Nausicaä is a typical Miyazaki heroine – strong-willed, brave, respectful of her environment and, as a leader, she demonstrates deep concern for her people. Hisaishi Joe (Fujisawa Mamoru) composed the soundtrack, using his electronic music talents to provide themes reminiscent of primitive music that is distinctively otherworldly. *Nausicaä* was hugely popular when it was released in the cinema and remains one of Miyazaki's most admired films in Japan.

Night on the Galactic Railroad
(Ginga Tetsudō no Yoru [1985]*)*

Directed by: Sugii Gisaburō
Feature film, 113 mins

Giovanni is a teenager with many problems. He's being bullied at school (although he receives support from his best friend Campanella), he has to work hard at his job, his father is away on an expedition, and he's worried sick about his sick mother. To make matters worse, her daily delivery of milk has not arrived. Giovanni tries to acquire the milk, but without success, and he is due to meet Campanella at the town's Star Festival. When he takes a brief rest on top of a hill, a mysterious train pulls up and he climbs aboard as a passenger. Campanella joins him and the pair embark upon a journey across the stars that will involve many destinations, many passengers, many staff and many situations; all of which will increase his understanding of the universe.

Night on the Galactic Railroad is based upon the posthumously published novel by Miyazawa Kenji, a multi-talented humanitarian, environmentalist and social activist who wrote a number of children's books and poems. Like much of his work, this been adapted many times in various forms, including anime. The adaptation to cartoon form is a sterling example of how anime can appeal to a variety of audiences and yet remain internally consistent as an artistic work. As with many of Miyazawa's stories, the plot can be viewed on a number of levels and there are subtexts and deeper issues to explore beneath the principal tale, which is ostensibly based around a fantastical journey. The primary theme is that of self-sacrifice but it is introduced to us in a very subtle way. When Campanella mysteriously climbs aboard the train to join Giovanni, he appears to be soaking wet but cannot explain why this is. It is only at the film's denouement that we understand the reason for this.

Giovanni's journey is an episodic one that takes him to a number of very different locations where he and Campanella encounter

many strange and interesting characters. The most notable are a man and two children who board the train, and we come to learn that they have drowned when their ship hit an iceberg and seem to be on their way to another life. This element seems a little incongruous at first, because of the sudden human involvement, for *Night on the Galactic Railroad*'s central characters are actually bipedal cats. However, this does not alter the emotional or artistic value of the film, but rather adds to its wonderful sense of otherness. This is enhanced by the remarkable score, which combines notable classical themes, integrating them with avant-garde compositions, accentuating the balance between past and future.

Beautiful, haunting and bittersweet, *Night on the Galactic Railroad* is a film that is both delightful and tragic. The little touches, such as the signs written in Esperanto, referring to Miyazawa's enthusiasm for languages, are what make it such a rewarding viewing experience. Sugii Gisaburō (a veteran of early *Astro Boy* anime) has created a film with a genuine sense of wonder that is believable and crosses cultural barriers. Literature for children, animated for adults in a way that understands spirituality, sacrifice and, above all, the power of the imagination. Especially if you like cats.

Other animations based on Miyazawa's works include the wonderful *Gōshu the Cellist* by Takahata and the Studio Ghibli short film *The Night of Taneyamagahara* by Oga Kazuo.

Devilman: The Birth (Debiruman tanjō hen [1987]) and The Demon Bird (Debiruman yōchō shirēnu hen [1990])

Directed by: Iida Tsutomu
OVA, 50 mins/60 mins

Devilman is, as his name suggests, a man who is also a demon. He is scary and savage – with wings, a sharp tail, claws and fangs that can wrench supernatural creatures asunder. But, ultimately,

he uses his evil powers to do good, using his titanic strength to destroy beasts of a spiritually nasty nature. An unusual character if ever there was one, Devilman was created by Nagai Gō in his 1972 manga. A TV anime series soon followed, as did a pair of later OVAs, both of which were overseen and approved by Nagai himself.

Nice guy Akira doesn't really know much about the supernatural, although real life has enough bullies and bunny killers to make up for that. But, after an encounter with his old friend, the somewhat suspicious Ryō, who convinces Akira that his father has discovered the presence of demons and asks him to witness the horrific bestial atrocities of a Sabbath, he finds that he's much more aware of the demonic world. The young man survives the horrendous ritual by becoming possessed by a devil but, because Akira's heart is true, he becomes a new spiritual being, a host to a satanic self, Devilman, who is strong, mean and able to obliterate anyone in his path. Especially demons...

Devilman is notably nasty in its instigation because that characteristic is fundamentally part of the protagonist's nature, but this is what makes the character such an interesting anti-hero; he's such a contrast to Akira, who is a genuinely nice guy. Much of Nagai's work is quite graphic and *Devilman* is no exception, with its gore-drenched atrocities – guts are spilled, limbs wrenched off and blood flows in abundance. Sexuality and violence are integral to the premise as orgiastic encounters lead to the creation of these incredibly cruel creatures. The Demon Bird is a (predominantly) naked woman with demonic wings and bird-like feet and claws who threatens Devilman in the second OVA. Devilman endeavours to battle this winged adversary but she is a formidable foe. The OVAs very much hold true to the character, as agreed by its creator, with both formats showing a phenomenal range of atrocious creatures from an increasingly surreal animated bestiary.

The Tale of Genji (Genji Monogatari [1987]*)*

Directed by: Sugii Gisaburō
Feature film, 110 mins

Although many anime are either created especially for the format or based upon manga, a number of works of Japanese literature have been adapted for the format and *Genji Monogatari* is, perhaps, amongst the most auspicious. Arguably the world's first novel, *Genji Monogatari* is a mighty work (about *Lord of The Rings* size) written by the Lady Murasaki Shikibu over one thousand years ago. An adaptation from a book of that size into a feature-length film was never going to be easy, so we are only presented with about a third of the story and many elements have been heavily abridged. That said, it is a beautiful anime, and makes you yearn for a sequel or three.

Genji Hikaru is Emperor Kiritsubo's son but is not in a position of power, having been born to the emperor's lowly ranked, albeit favourite, consort. Genji's priorities lie with his social, emotional and physical desires, and the shining one takes every opportunity to engage in lustful exploits with as many of the court ladies as possible, including, just occasionally, his oft-neglected wife Aoi. It seems that, no matter how hard they might try to resist him, everyone desires Genji. Even his stepmother, Lady Fujitsubo, whom he truly loves because she reminds him of his mother, not only falls for his charms but also falls pregnant and, although their affair remains secret, it is noted that the crown prince bears an uncanny resemblance to Genji. Aoi also bears him a child but dies soon after. Still, the philandering continues and it is only a matter of time before he is found out.

The animation captures much of the essence of the book, providing a captivating insight into eleventh-century court life, with its emphasis on propriety, etiquette and discretion. To demonstrate this, the film depicts many scenes where we hear the gossiping of the courtiers but are only allowed to view the exterior of the room in which they are talking, the sound of the rain almost, but not

quite, drowning out their words. The design is excellent, from the traditionally attired central characters, be they courtiers, artisans or monks, to the natural environment, which appears to be almost photo-realistic at times. Feathers, leaves, petals and snow waft in the breeze, encircling the characters and their environment. When the wind agitates the smoke from Aoi's funeral pyre, it joins the clouds and the emotional malaise of the mourners. The mysterious spirit whose presence haunts the novel also makes an ethereal appearance here. There are also references to the many poems and the sprigs of flowers or tree branches that Genji used to communicate with his lovers as depicted in the book.

Rather like Ralph Bakshi's animated adaptation of *Lord of the Rings* (1978), *Genji Monogatari* halts abruptly, part way through the sumptuous tale, leaving the viewer wanting more. A TV series, *Genji Monogatari Sennenki*, directed by Dezaki Osamu, was released in 2009.

Urotsukidōji (Chōjin Densetsu Urotsukidōji [1987]*)*

Directed by: Takayama Hideki
OVA

Urotsukidōji has a reputation. Probably the best-known adult anime that has reached Western shores, it achieved a certain notoriety when it was released in the 1990s that pushed back the general acceptance of anime in the West for many years. It is an example of hentai, perverse and outré, which reflects the very diverse nature of the market that the format can appeal to.

In *Urotsukidōji* other worlds exist in parallel with our own. Human existence has an inextricable relationship with the Makai – a world of demons – as well as the Jūjinkai, the domain of hybrid beings who are capable of looking like humans or beasts and are no less scary in many respects. There is a legend that foretells that, every 3,000 years, the Chōjin shall be reborn, the godlike being (or 'overfiend' of the English-language title) who will reunite the worlds in an apocalyptic, pacifying rebirth. Man-beast Amano Jyaku and

his companions are searching for the Chōjin. At a high-school in the human world, student Nagumo is an apparently ordinary kid – shy, gauche, ridiculously bad at sports, horny but entirely unavailable to girls. He couldn't possibly be the Chōjin, could he?

Urotsukidōji undoubtedly has issues. It was adapted from erotic mangaka Maeda Toshio's manga but is a very different beast to that work, as director Takayama made significant changes to the plot. What this plot summary omits (for reasons of brevity) are the extensive scenes of sex and violence between humans, demons and man-beasts (who are strangely cartoonish in appearance and thus seem quite incongruous) and demons disguised as humans and... well, you get the point. Yes, it is explicit; yes, it is incredibly violent. Its tone is cruel and ruthless, but this is all within the context of the narrative. It has roots in the ero-guro (erotic grotesque) art tradition of the 1920s which actually has origins that reach further back into the history of Japanese art. For example, *The Dream of the Fisherman's Wife* is an ukiyo-e by Hokusai which features a woman in an erotic embrace with two octopuses.

Clearly appropriate for an adult audience only, and unlikely to appeal to a mainstream demographic, *Urotsukidōji* is not the pariah of the anime world that it was claimed to be but it does make for challenging viewing.

Royal Space Force: The Wings of Honnêamise (Ōritsu Uchūgun: Oneamisu no Tsubasa [1987]*)*

Directed/written by: Yamaga Hiroyuki
Feature film, 120 mins

The first feature produced by Gainax and written/directed by one of their founders, Yamaga Hiroyuki, *The Wings of Honnêamise* is a drama about the development of a pioneering space programme but launches it within a fantasy world that is similar to, albeit distinct, from our own.

Lhadatt Shiro, a member of the Royal Space Force, doesn't have very much respect for authority. In some ways his attitude is understandable as the Space Force isn't highly respected, his

leaders are self-centred and his country is on the brink of war. Shiro develops a close friendship with Nonderaiko Riquinni and her daughter Manna. Riquinni is deeply religious and persuades him to strive and work hard at his endeavours in the Royal Space Force. Shiro is promoted to become the first pilot in Honnêamise's quest to reach outer space, a centre of media attention and, whether he likes it or not, is inevitably involved with his country's actions as they seek a dominant position in the world. And so the space programme begins in earnest, with intense training for Shiro as well as the engineers who endeavour to overcome the technical challenges that lie ahead. But is the space programme actually just part of government propaganda and the rocket a military tool to goad Honnêamise's rival nation, The Republic? Only time will tell.

With a deceptively simple storyline (Yamaga's film is based upon his own short story), this is a surprisingly complex piece, taking into account both personal endeavour and broad political issues. It was an expensive production, which is perhaps surprising given that the film was the premiere feature by a group of animators who had only recently become professionals, but the cost is reflected in the epic format, even if the box-office returns for the picture were not impressive. The plot bears similarities to *The Right Stuff* (1983), a live-action film about the pioneers of the American space programme, but the strength of this film is that Shiro does not fit the heroic elite persona that is usually demanded of such a protagonist. He is rather simple (the Not-So-Bright Stuff perhaps) and finds it difficult to deal with his celebrity status following the declaration of his role as the first space cadet in the media. His concern about his responsibility and the publicity that surrounds him is the catalyst for the development of his relationship with Riquinni, but this turns sour when he attempts to sexually assault her, something she eventually forgives him for.

The animation is top quality, as is the implementation of strong characterisation and design. *The Wings of Honnêamise* is an example of science-fantasy anime as art-film narrative, combined with a coming-of-age drama that is intelligent and thought-provoking.

Kimagure Orange Road (1987–88)

Directed by: Kobayashi Osamu
TV anime, 48 episodes

Kasuga Kyōsuke is the new kid in town who has recently moved into the area with his father, twin sisters and Jingoro, their portly and somewhat long-suffering cat. The teenagers are about to start classes at the local school. It turns out that Kyōsuke already knows one of his new classmates – Ayukawa Madoka, who he recently encountered at the top of the steps at a local park. The family soon settle into their new home and make new friends. Kyōsuke is very attracted to Madoka but soon earns the attentions of her friend, Hikaru, who immediately decides that they should become a couple and constantly refers to Kyōsuke as 'daaarling', leaping into his arms at every opportunity. One thing Kyōsuke remains very cautious about is that his family should keep their secret power – special skills that enable them to perform superhuman feats, including telekinesis and time travel – a secret.

Kimagure Orange Road is a gentle coming-of-age drama, an episodic combination of sitcom and teenage romantic soap opera with a fantasy twist and lots of laughs. It is essentially the story of a love triangle – between Kyōsuke, who is infatuated with Madoka, but has to endure the attentions of the vivacious and mildly irritating Hikaru, whom Madoka will not hurt for the world. Actually, it's more of a love square, because Madoka and Hikaru's childhood friend, Yūsaku, is very much in love with Hikaru, who is entirely oblivious to his attentions. Kyōsuke is a genuinely sweet character and so well intentioned, but it is Madoka, who used to be a rebel and still has to endure the occasional fracas with her former gang's rivals, who steals the show. She is plucky, determined, principled, occasionally violent and plays a mean riff on the saxophone. Most of her classmates are scared of her – no wonder Kyōsuke is smitten.

Each episode is pretty much self-contained, but what makes the series particularly endearing is the regular cast of minor characters,

such as the hapless couple, Ushiko and Umao, who declare their love for each other virtually every episode only to have their romantic encounter thwarted by one of the teenagers, which just adds to the charm. And around halfway through the series we are introduced to Kazuya, Kyōsuke's younger cousin, who is telepathic and provides additional problems for the characters with his naughty pranks and brutal honesty.

As a romantic comedy with telekinesis, *Kimagure Orange Road*'s strong points are the humour and the romance. And the telekinesis.

Akira (1988)

Directed by: Ōtomo Katsuhiro
Feature film, 125 mins

For a certain generation of Westerners, *Akira* represents *the* introduction to anime. Previous incarnations of the format had been restricted to children's entertainment that were inevitably dubbed and frequently edited for content. When *Akira* appeared on the big screen it demonstrated that anime could offer something different – not only for fans of science-fiction and action but also the art-house crowd – and to great acclaim. From its intense plotting and compelling characterisation to the technical realisation of the animation process that, even after decades of CGI development, are still remarkable in their execution, *Akira* has not dated a jot.

By the year 2019, 31 years after its destruction, Neo-Tokyo has re-emerged as a densely populated metropolis of citizens trying to live with some degree of normality. Enjoying life in the fast lanes of the city are the Capsules, a bōsōzoku (biker) gang led by Kaneda, whose rival biker-bozos, the appropriately named and attired Clowns, are fighting over territory. Following a run-in with the Clowns, Kaneda's best friend Tetsuo loses control of his bike and crashes into an ancient-looking 'child', ending up in a military hospital. He develops seriously strong psychic powers that are somehow linked with Akira, the young 'boy' responsible

for the initial destruction of Tokyo. With Tetsuo's mental condition deteriorating fast, there's a strong possibility that further shocking, psychologically controlled destruction could well ensue, rendering Neo-Tokyo a steaming rubble of cursed wilderness once more. But how much can Tetsuo really understand of his own abilities, if indeed they are really there? Can Kaneda engage with his buddy and prevent another apocalypse?

There are many reasons to praise *Akira* but key to its success is the manner by which it takes so many themes and concepts, gelling them together to create a consistent and immersive whole that portrays intriguing characterisation mixed with an occasionally bewildering array of stunning visual techniques and action sequences. The destruction of Tokyo, by the unseen Akira, is representative of the nuclear bombings that destroyed Hiroshima and Nagasaki, before the film launches into youth bōsōzoku gang violence and street-biker fetishism that is about coolly reprehensible youth gangs mixed with action-cinema-style cutting and composition. The speed and pacing of the biker action combines with the hipness of underground live-action films of the exploitation variety as produced by the Nikkatsu Corporation. *Akira* works because its narrative develops into something far more complex, its science-fiction background, psychic revelations and cross-genre mixing of visual aesthetics developing into a vision of a surreal and vicious future. Also of note is the superb soundtrack which similarly demonstrates an eclectic variety of styles (from choral to energetic heavy metal) without becoming a confusing hotchpotch. *Akira* is nothing short of a visual, aural and intellectual assault on the senses and remains an intensely rewarding experience.

Grave of the Fireflies (Hotaru no haka [1988]*)*

Directed by: Takahata Isao
Feature film, 89 mins

During the closing months of the Second World War, Japan is being bombed relentlessly by the Allies, reducing its cities to rubble with

dispassionate devastation. In Kōbe, Seita and his younger sister, Setsuko, manage to avoid one of the latest bombing raids, but their mother is not so fortunate. She dies from her wounds in front of Seita. The boy decides to hide the news from Setsuko. In order to survive, Seita seeks shelter with their aunt but does not participate in the household's duties and leaves with Setsuko to live in a disused air-raid shelter. The pair exist on stolen food but they are both becoming malnourished and their outlook is bleak.

Grave of the Fireflies was double billed with Miyazaki's masterpiece, *My Neighbour Totoro*, at a time when Studio Ghibli was beginning to establish itself as a viable production studio. Based upon the novel by Nosaka Akiyuki, this is a semi-autobiographical work written by the author to address his own guilt over the death of his sister during the war. Although not strictly a war film, in that we are never shown actual scenes of conflict, *Grave of the Fireflies* does show the effects of war and the way that it can dehumanise people. The film is almost claustrophobic in its focus on the two siblings who are utterly believable but tragically flawed characters. It is uncomfortable to watch, not just because of the extraordinary circumstances they find themselves in, but because their misguided decisions are all too real and could so easily have been avoided. Seita is desperately protective of his sister, but too proud to accept help.

The titular fireflies appear towards the film's end. A flashback shows the siblings catching fireflies in happier times and, in a brief moment of cheerfulness, they try to grasp the elusive insects whilst camping out at the shelter. But, like Setsuko, the firefly is a creature with a life that is far too short. The firefly glows with a brilliant flame then fades away – a fitting metaphor for the children.

A very honest film, *Grave of the Fireflies* is narrated by Seita post-mortem – we see his death at the very start of the film. This is a film about the consequences of war that is both deeply moving and poignant.

My Neighbour Totoro (Tonari no Totoro [1988]*)*

Directed by: Miyazaki Hayao
Feature film, 86 mins

Satsuki and her younger sister, Mei, have just moved to an old house in the countryside. They need to be close to the hospital where their poorly mother is convalescing. One day, while playing in the garden, the thoroughly adventurous Mei comes across a strange creature and decides to follow it through a corridor of trees under the shadows of an enormous camphor tree. There, resting on his back, is a huge snoring Totoro, slowly coming to wake when he realises that a curious Mei is lying on his chest. Telling her sister of her encounter, the girls form a friendship with the spirits of the forests and learn to live in harmony with their environment.

Quite simply one of the most magical films ever created (and not just within the anime format), *My Neighbour Totoro* is gentle, charming and moving. Miyazaki introduces us to our main characters – Mei and Satsuki – who are delightful and exuberant, and then sets his imagination free as he shows us their secret friendship with the creatures who live alongside them. It is Mei's natural curiosity that leads her to follow one of the smaller Totoros dashing through the garden until she stumbles across O-Totoro, rotund and grey, who may be very furry but he has a mighty roar.

The most iconic moment of the film comes when the girls are standing at the bus stop in the rain, waiting for their father to arrive home. They are joined by Totoro, whose leaf is entirely unsatisfactory as an umbrella, so they give him one of theirs. It's not long before a multiple-limbed cat, with headlights for eyes and a broad toothy grin, bounds down the road, and opens up a door in his side, allowing Totoro onboard. Later the girls will get to ride in Nekobasu (cat-bus).

The woodland spirits within this countryside environment are completely natural. There is a sense that Mei and Satsuki can see Totoro and his friends because they are children but also because they are respectful of their environment, something that mankind in

general has failed to be. They bow to the sacred tree and show no fear of the spirit world; they have true affinity with their surroundings.

My Neighbour Totoro started out as a small, personal film for Miyazaki but has since become a national institution, and Totoro eventually became the mascot for Studio Ghibli. It is a rare film – one that is suitable for all ages and genuinely delightful.

The Sensualist (Kōshoku Ichidai Otoko [1990])

Directed by: Abe Yukio
OVA, 55 mins

The Sensualist is a sumptuous drama based upon the late-seventeenth-century novel *Life of an Amorous Man* by Ihara Saikaku.

Yonosuke, a prosperous merchant, is well versed in the art of fornication and known for his amorous excesses and sexual prowess. His servant Juzo is not so enlightened, though not for want of trying, a matter that becomes more important for him when, in a rash drunken bet, he gambles his manhood, and hence any future carnal activity, on whether he can sleep with the famous courtesan Komurasaki on their first encounter. The chances of bumpkin Juzo bedding such a bourgeois beauty are decidedly dubious, but his employer just happens to know the refined lady and may well be able to negotiate some assistance that will not only enhance his pride but also allow him to hang on to his member. Only time, and perhaps a certification of lovemaking, written on his underpants in the most distinct calligraphy, will curtail any sticky outcome…

At its heart (or should that be loins?) *The Sensualist* is an erotic drama but with comic elements that are as much based on tradition as the period setting and the source material. Art plays a vital role in *The Sensualist* – the whole feels like a languid ukiyo-e print in its recreation of the Edo period and also its depiction of nature; from the images of crows and maple leafs to Yonosuke's ship-bound journey that notably and humorously recalls Hokusai's *The Great Wave off Kanagawa*. The carnal scenes are similarly

represented in a manner that is artistically realised, enhanced by the illustration of sexual organs emerging as other entities of nature, such as flowers or animals, which are symbolic and iconic. We first encounter Komurasaki dressed in a lush red kimono accompanied by her attendants. She glides through the building; far more than a prostitute, she is elegant and cultured, well versed in the arts of entertainment – dancing, singing, conversation.

As the title indicates, this is a film that features intrinsic elements of sexuality. However, despite the often bawdy situations and graphically inspired encounters, the whole comes across as sensual erotica rather than pornography. *The Sensualist* is a wonderfully realised example of anime as heritage literary cinema that still manages to embrace its source's sensuality and humour amidst its artistic depiction of its period, its class and its people.

Sailor Moon (Bishōjo Senshi Sērā Mūn [1992–93]*)*

Directed by: Satō Junichi
TV anime, 46 episodes

Usagi is a 14-year-old schoolgirl who is a bit of an airhead but has a good heart. School life is filled with the usual problems of boys and exams but there is a wider issue facing not only Usagi but also the rest of the world: evil of a spooky kind can be found in the Dark Kingdom, run by monarch of atrocity, Queen Beryl, who wants to drain humans of their energy. One day, Usagi encounters a cat – which wouldn't seem to be a big deal, but this cat is Luna, who has a crescent-shaped feature on her forehead and impressive conversation skills. Luna reveals that Usagi has the ability to fight evil because she is a sailor warrior. Provided with special items that will aid her transformation from tearful teen to Sailor Moon, she has a range of enemies to confront. Further sailor warriors join Usagi and together they fight evil in all its forms, aided (or are they?) by the charming and mysterious (or is he…?) Tuxedo Kamen.

Sailor Moon is a shōjo anime aimed at a younger audience. Initially it retains the same format each week with the enemies devising a

new means of draining energy from the town's denizens. There are repetitive elements, notably Usagi's transformation from schoolgirl to super-girl or the casting of her Moon Tiara Action strike. But once it gets going, it's a fun, light-hearted story. The conflicts, whilst often resolved by the sailor warriors, are frequently sorted by the gorgeous bishōnen figure of Tuxedo Kamen, who steps in when the girls have run out of steam confronting their demonic opposition, leaping in to save the day with his disguise and cape. Also important are the supporting characters and their relationships with Usagi – her parents, her younger brother and – especially – the other sailors. The girls may work together but they don't half bicker when they're not fighting evil, which adds to the humour in the series.

Sailor Moon's popularity led to feature-length adventures and further series – *Sailor Moon R* (1993–4), *Sailor Moon S* (1994–5), *Sailor Moon Super S* (1995–6) and *Sailor Stars* (1996–7). The series also had a prominent release outside Japan and was hugely popular in the West.

The Cockpit (1993)

Directed by: Kawajiri Yoshiaki, Imanishi Takashi and Takahashi Ryōsuke
OVA, 90 mins

Whilst World War Two has often been depicted in anime in terms of the horrific and emotional effects upon the innocent victims of war, in films such as *Grave of the Fireflies* and *Barefoot Gen*, *The Cockpit* takes a different approach to the subject and shows us the emotional and moral decisions that face those directly involved in battle. *The Cockpit* anthology comprises three OVAs with separate characters, stories and perspectives, and places them in a wider emotional, moral and (light) philosophical context.

The three stories, based upon the Battlefield manga by Matsumoto Leiji, follow different perspectives on roughly the same theme, the cockpit of the title being more related to the aeroplane-based segments that are the primary themes of two

of the stories. They relate to historical events, though they are in themselves fictional. The results are as engaging as they are questioning. *Slipstream* (Kawajiri Yoshiaki) has a Luftwaffe pilot with issues regarding both his abilities and actions as he recovers from near-death experiences in the sky (wonderfully animated in a manner that is tense and often tight in its revelation of survival) and his relationship with a fellow Nazi, as she reveals his future mission to engage in Germany's frightening experimental atomic annihilation plan, and his decision to thwart it. The atom bomb is also relevant to *Knight of the Iron Dragon* (Ryōsuke Takahashi), set after the Hiroshima bombing and depicting two Japanese soldiers, ignorant of current events, who endeavour to reach their base on their motorcycle and sidecar. The mission is futile but they return to their comrades, having sworn never to retreat, and, although their personalities appear comic because of their cartoonish character design, their determination is real. These two stories frame the middle episode, *Sonic Boom Squadron* (Imanishi Takashi), which is, perhaps, the most affecting of the three. Like *Slipstream* this episode explores the inner conflict between its protagonist and the cultural and military orders that require him to fulfil his role in the war. Its central character faces a distressing dilemma, for he needs to eject from another plane in a Yokosuka MXY-7 Ohka in order to complete his mission. His understandable emotion conflicts with his kamikaze duty as he needs to prove himself as a loyal fighter.

The Cockpit's strength lies with the fact that it is not politically biased and does not portray any viewpoint as correct. It depicts shocking aspects of military violence but shows us the ordinary people who are involved as they try to come to terms with the requirements of their role. They are human. They have worries and opinions. Emotional, thoughtful, dramatic, well animated and addressing a multitude of perspectives on a worldwide conflict, *The Cockpit* is essential viewing.

Ninja Scroll (Jūbei Ninpūchō [1993]*)*

Directed/written by: Kawajiri Yoshiaki
Feature film, 94 mins

Kawajiri Yoshiaki's anime is a hyper-violent, bloodthirsty excursion into the realm of ninja but cannot simply be described as exploitation cinema, as its careful use of plot and characterisation generates a piece that engages the mind even as the screen is drenched with the flow of blood.

Jūbei Kibagami is a rōnin with incredible ninja skills and a strong sense of justice. He was part of a team led by Gemma Himuro, but a gold-hunting excursion to benefit the Yamashiro clan turns sour and his near death leads him to decapitate the treacherous Gemma. But Gemma is reincarnated and returns as a sadistic leader of the Devils of Kimon, a group of demonic ninja with a lust for gold and a barbaric means of acquiring it for their boss, the Shogun of the Dark. Jūbei encounters feisty ninja, Kagerō, official food taster to the Chamberlain, who is trying to protect a rural village from demonic rape. Jūbei is persuaded to join the battle to defeat the Devils of Kimon by the devious Dakuan, who gets Jūbei on his side by poisoning him, promising to give him the antidote only after the job is done. Kagerō joins up to help Jūbei, although she doesn't need to be coerced with poison as she is immune. Jūbei has a difficult task ahead, and can he really trust Dakuan to provide the cure?

Certain visual aspects of *Ninja Scroll* are ideally suited to anime because they would be difficult to achieve in live-action filmmaking in a convincing (or at least affordable) way, although elements of its visual style do recall earlier Japanese live- action films, notably those of the early to mid-1970s, such as *Lone Wolf and Cub (Kozure ôkami* [1972–74]), *Lady Snowblood (Shurayukihime* [1973–74]) or *Hanzo the Razor (Goyôkiba* [1972–74]). Bloodletting is a fundamental part of the violence depicted, a fountain of crimson spray that hoses the scenery in excessive detail. In many respects, this recollection of 1970s live action extends into the depiction of sexuality within the

plot integration in a manner that is often distinctly problematic in its portrayal. Indeed, the film was originally cut in the UK. Although the sexual assault on Kagerō and her rescue by Jūbei could be seen as masculinity personified in the actions of its testosterone-enhanced lead, *Ninja Scroll* gives us a stronger characterisation of Kagerō than would otherwise have been assumed. She has a steadfast personality and prodigious combat skills and is a welcome addition to the team. The way that she and Jūbei deal with their situation and, in Jūbei's case, specifically with the cure for his poisoning, makes for a film that does not skirt difficult issues but ensures that their portrayal does not dominate proceedings. Instead this is plot- and character-based anime that is broad in scope and which at times, despite the normal feature length, feels almost like the adaptation of a larger work.

Written and created by Kawajiri Yoshiaki, *Ninja Scroll* remains his most renowned work. Kawajiri also wrote *Ninja Scroll: The Series* (2003). He started out as a key animator on a huge number of projects including *Ashita no Joe*, *Barefoot Gen* and *Future Boy Conan* (1978). He also wrote and directed a segment from *The Cockpit* as well as *Vampire Hunter D: Bloodlust* (2000) and he designed and directed *Wicked City* (1987).

Pom poko (Heisei tanuki gassen pompoko [1994]*)*

Directed by: Takahata Isao
Feature film, 119 mins

The Tama New Town Project may be an urban development that reflects Japan's increasing prosperity, but not all of its residents are happy about the economic boom. The tanuki (raccoon dogs) lands are disappearing fast, their once-harmonious co-existence with the humans vanishing in a waft of consumerism and urban sprawl. The remaining tanuki initially battle for what little territory remains but eventually decide to pool resources and take a pro-active approach to the problem. The fun-loving tanuki decide to revive

their transformation skills in order to sabotage the construction and scare away the humans. But, despite their worthy attempts, the development continues apace and time is running out...

Tanuki are held with great affection in Japanese folklore. They are fun-loving, playful characters that are always up for a feast and a party. They have the ability to transform into anything they wish, should they be talented enough, and if they can be bothered. The tanuki celebrate their victories using their large, round bellies as drums to beat out music. Indeed, the term pompoko is onomatopoeia for the belly-drumming sound. They don't have the cunning of the kitsune (foxes), who have decided to transform permanently and join the 'rat race'.

Like many of Ghibli's films, *Pom Poko*'s primary theme is concerned with the environment, looking back to a time when humans and tanuki lived in harmony, and criticising the consumerism of the present. The animation style varies according to the form the tanuki choose to take when they transform. The mythology is such that they are naturally bipedal, but tend to walk on all fours in the presence of humans. The animation matches their real-life counterparts when in this state, but the tanuki become anthropomorphised when we see them interact with each other, the animation moving seamlessly between the various styles.

The film is chock full of cultural references and mythologies. There are allusions to Japan's main religions – Shintō and Buddhism – and many tanuki transform into yōkai, most notably during the spooking parade as they try to drive the humans away – to no effect. Bittersweet but yet somehow filled with a hesitant joie de vivre, *Pom Poko* is both a lament for Japan's past and acknowledgement of its technological future.

Ghost in the Shell (Kōkaku Kidōtai [1995])

Directed by: Oshii Mamoru
Feature film, 92 mins

Major Kusanagi is mainly cyborg, but her human form belies her (if indeed a cyborg can be female – her visual appearance suggests

this) considerable skills in Section 9, an elite police unit. She is currently working on a case with her colleagues, to track down the Puppet Master, an elusive hacker whose nebulous activities have the potential to cause a political fracas, hacking into 'shells' – physical entities which can contain a brain/soul – to steal their identities. This appears to be connected with the mysterious Project 2501. The team locates a shell that has been hacked into and uses it to learn how the Puppet Master's consciousness evolved and how it needs a host body. But the shell is stolen by another government unit, Section 6. A confrontation between all parties is inevitable, and Kusanagi is faced with a difficult dilemma.

The combination of film genres within a highly complex structure is what makes Oshii's adaptation of Masamune Shirō's science-fiction drama so compelling. Praised by director James Cameron as 'the first truly adult animation film to reach a level of literary and visual excellence', this may seem to be a frivolous statement but *Ghost in the Shell* is, as the director of *Titanic* (1997) and the clearly anime-inspired *Avatar* (2009) suggests, precisely that. From the animation, scripting and characterisation perspectives *Ghost in the Shell* succeeds on a variety of levels – regardless of its ostensibly science-fiction backdrop it is, in many ways, a modern film noir for a computer-literate generation: Philip K Dick meets Raymond Chandler, if you will. The central character is a cyborg that recognises her own sentience. This is the film's essential theme – it asks sophisticated philosophical questions about the perception of existence and what it is to be human.

Ghost in the Shell's design and animation are remarkable in their depiction of futuristic environments that are at once familiar and otherworldly. The film combines spectacle and violence with mundane aspects of human existence. It has become a quintessential anime in terms of scientific and psychological perspectives of multi-cultural attitudes and personal awareness. The success of the film resulted in the television series *Ghost in the Shell: Stand Alone Complex* (1996 onwards) as well as a fantastically artistic, psychologically challenging sequel, *Ghost in the Shell 2: Innocence*

(2004). This depicted additional aspects that enhanced the political stance of its progenitor, and refined the more existential analysis of character and political motivation.

Whisper of the Heart (Mimi wo sumaseba [1995]*)*

Directed by: Yoshifumi Kondō
Feature film, 111 mins

Avid reader and burgeoning writer Tsukishima Shizuku has a mystery to solve. Every time she borrows a book from her library it appears that someone called Amasawa Seiji has read it before her. She has a lot on her plate at the moment – trying to keep up at school, and she also needs to help with the chores at home. One day, while taking a *bento* (lunch box) to her father's workplace, she is joined on the train by a plump white cat. She follows him and chances upon a wonderful antiques shop. The owner, Nishi Shirō, shows her the marvellous items in his shop, including the recently restored statuette of the Baron, a noble, aristocratic, bipedal cat with a top hat, tails and a cane. Even more amazing, the most irritating of the boys at her school is Shirō's grandson… and he just happens to frequent the local library.

Whisper of the Heart is the only feature film directed by the late Yoshifumi Kondō, a talented animation director, designer and artist who joined Studio Ghibli in 1987. It's a lovely coming-of-age drama (most of which could actually have been filmed as live action) that explores the process of creativity and artistry.

It is the rich characterisation that makes this film so delightful. Both of the young protagonists are at an age where their lives are full of possibilities. Seiji is a talented violinmaker and wants to train as an apprentice in Italy. Shizuka has no idea what she wants to do with her life but, inspired by Seiji's determination, she sets about writing a book: a novel about the Baron. The way the pair's friendship develops is portrayed with such accuracy – Shizuka's embarrassment and indignation at Seiji's teasing, then discovering a genuine companionship, followed by hopes of a burgeoning

romance. Indeed, one of the most charming scenes of the film occurs when Shizuka visits Seiji's workshop. He picks up a violin and plays it as Shizuka plucks up the courage to sing 'Country Roads'. It is genuinely moving, particularly when Nishi and his musician friends join them.

Perceptive, sweet and utterly delightful, *Whisper of the Heart* is essential viewing. If you liked this, try *Only Yesterday* (1991), another Ghibli film which tells the tale of Taeko, an office lady who visits the countryside and recalls the days of her youth.

Neon Genesis Evangelion (Shin Seiki Evangerion [1995–96]*)*

Directed by: Anno Hideaki
TV anime, 26 episodes

Fourteen-year-old Ikari Shinji has issues. School is problematic and he doesn't really get on with his father. Still, his dad has found him a job. Shinji is to be a pilot on an Eva, a mecha that is needed primarily for confrontational purposes: to defend the Earth from attack by the Angels – brutal intergalactic warriors that have decimated not just Tokyo but the whole world in the years since their first encounter with Earth. Shinji, along with the other child pilots, introverted Rei and little madam Asuka, is to join NERV, the organisation run by his father to defend against the Angels. But with the combination of completing his schoolwork, getting on with his boss (the lovely but slovenly Misato) as well as his co-pilots, wanting to please his father and, of course, saving the world, could the pressure on Shinji prove to be too much?

Neon Genesis Evangelion succeeds on a number of levels. The summary above does not even begin to touch upon the complexity of the plot structure, the depth of the characterisation, the multifaceted questions about the nature of existence, or even the raw emotion that the series presents. The attention to detail is remarkable considering the density of the story – from the incessant background

dirge of the cicadas to the antics of the long-suffering Pen Pen, the pet penguin, who provides comic relief – but these details make the whole so rich and rounded. Audience engagement is primarily driven through the characterisation – the central protagonists are schoolchildren but they have to work in an adult world – a world of big science, defence organisations and shady corporations. Key to this is the brilliant interaction between the characters and how they relate to each other. The first half of the series introduces us to the characters and the concepts of the Angels as well as giving us an understanding of Earth's new society and the organisations set up to protect it. The series then turns to asking deep philosophical questions prompted by the characters', predominantly Shinji's, angst and incorporating multicultural religious connotations questioning the nature of humanity and the soul. This aspect of the screenplay mixes multi-dimensional battle violence with existential philosophy even as the teenage central character is beginning to understand the difference between his professional responsibilities, family feud and his far from normal social life.

Evangelion truly is a gripping combination of drama mixed with futuristic apocalyptic technological angst, with a smattering of comedy and tragedy that makes for utterly compelling viewing.

Black Jack (1996)

Directed by: Dezaki Osamu
Feature film, 105 mins

Black Jack was created as a manga in the 1970s and his popularity endured, with subsequent OVAs and TV series. This is the 1996 version directed by Tezuka's protégé Dezaki Osamu.

The Olympics showcase the zenith of athletic prowess and the latest games are no exception. Indeed, world records are being smashed as new athletes, super-humans who pass every doping test, demonstrate their amazing abilities. But where have they come from and what are the potential consequences of their peculiar

proficiency? And, just a few months later, why are they withering away, deteriorating in an institution? It's time to call dapper super-surgeon Black Jack, whose companion Pinoko has been kidnapped by Brain corporation to ensure his co-operation. Jack must try to understand the medical reasons behind the athletes' enviable aptitude and increasingly short life-expectancy.

The deeply mysterious Black Jack is a fascinating character who was originally created by Tezuka Osamu (there's an Astro Boy cameo here if you look hard enough). Jack is a private doctor, a medical expert and therefore an intelligent and skilled practitioner whose ultimate aim is to ensure the well-being of his patients, but his motivation also appears to involve maintaining his comfortable lifestyle and, of course, the respect of his peers. In many ways he is a phantasmagorical character; visually he bears a definable facial scar and shock of black and white hair and he wields his scalpel like a samurai's katana (sword). The film does not balk at showing us the details of the surgery (indeed the production used medical advisors, adding realism to what is ultimately a biological science-fiction story), but its depiction is never gratuitous and the fantastical elements are given a sense of believability within the carefully constructed plot.

The combination of artistic design and careful animation place the normality of athletic events, city-based commerce, politics and media against a background of superhuman abilities and nefarious evil genetic medical master plans, and this is what makes *Black Jack* such an interesting film. Jack never becomes super-human himself, despite possessing almost super-human skills, and he never becomes ridiculously virtuous or overtly amoral – a macabre, but strangely convincing, hero.

Cowboy Bebop (1998)

Directed by: Watanabe Shinichirō
TV anime, 26 episodes

'Okay, three, two, one, let's jam.'

Earth is as good as gone, at least as a residential planet, so most of those who survived its devastation have had to pick from a variety of alternative places to stay. The new solar system society, based around Mars, brings with it a bunch of crime and there are those who seek to curtail this excess of law-breaking. The police have enough to do, so bounty hunters in search of hard Woolong (i.e. currency) travel the galaxy in search of criminals (aided by tacky TV show *Big Shot for the Bounty Hunters*, which provides the lowdown on the most heinous henchmen), even though their own activities may be less than entirely scrupulous. And some of these live aboard the spaceship known as the Bebop. Distinctively coiffured Spike Spiegel is the easy-going, kick-arse fighter, a stoic hero with an interesting past whose pal, tough guy Jet Black, has a deeply scarred head and cyber appendages. 'There are three things I particularly hate. Kids, animals, and women with attitudes. So tell me, Jet, why do we have all three neatly gathered on our ship?' Yes, joining the dynamic duo are foxy Faye Valentine, a gambler who seeks Woolong by any means necessary, even if her multiple decades of suspended animation actually make her pensioner age. Then there's young Ed, computer hacker extraordinaire and occasionally overly enthusiastic addition to the Bebop; just don't mistake her for a boy. And not forgetting Ein, a corgi who is far, far more than just a pet.

Mixing a variety of concepts and genres but remaining hugely enjoyable in its own individualism, *Cowboy Bebop* takes on a number of elements that initially seem to be a variant on the ever-popular and enjoyable anti-hero premise. It has a central character, complemented by a number of comrades who are often involved as much for reasons of self-interest as they are from a desire to achieve a satisfactory outcome for the group. Although Spike is ostensibly the lead character, *Cowboy Bebop* soon develops as a series where the individual members of the team become distinct in their own right, and the whole contains a number of episodes where important revelations and relationships evolve in the narrative.

This, then, is as enjoyable and eclectic as its soundtrack – which is hugely important to the series as each episode is named for a

genre or song. It's old school mixed with sci-fi. *Cowboy Bebop* runs for a self-contained 26-episode series and provides a completed story. As with many anime TV series, the episodes (especially the earlier ones) can be viewed in isolation, but each contributes to the whole, particularly in terms of characterisation, and therefore provides narrative drive. An anime feature film, *Cowboy Bebop the Movie*, followed in 2001, and a live-action Hollywood version has been in and out of development for many years. If you like this, check out *Trigun* (1998), a similarly enjoyable sci-fi western.

'See you, Space Cowboy...'

Serial Experiments Lain (1998)

Directed by: Nakamura Ryūtarō
TV anime, 13 episodes

Both farsighted and frighteningly avant-garde in its depiction of technology, *Serial Experiments Lain* is the linking of William Gibson's *Neuromancer* to the normality of everyday Japanese school life. It doesn't contain the cyberpunk and violent implementation of that seminal work but rather comprises the unravelling of a dominant culture both in and out of cyberspace where the demarcation between existential awareness and even the concept of being is unclear. Is the self a corporeal individual or a multitude of faceted incarnations, albeit with recognisable aspects of personality, within varied perceptions of world and existence? Intense philosophical ideas combine with science-fiction and a contemporary school-based setting and, in *Serial Experiments Lain*, these revelations are rife with existential angst both for the viewer and the protagonist. However, despite its often deep, or at least confusing, plot revelations, it is never patronising or deliberately confrontational.

Lain is an ordinary schoolgirl. One of her classmates, Yomoda Chisa, has died recently, a suicide, but she's someone Lain didn't really know until after her death when visions and recollections begin to influence Lain's life and she becomes aware of another

world, The Wired. The Wired is a network of networks, a cyberspace which Lain starts to explore. But, as she becomes embroiled in this new world, this timid girl discovers a wider context to her existence, her interaction with the people in it, and its links with reality itself.

Wonderfully realised, *Serial Experiments Lain* is the anime that initially depicts a conventional high-school story then rejects this premise for something that is altogether more sophisticated. It remains entirely relevant since its initial broadcast over a decade ago. Philosophically and intellectually, the concerns of the characters who become embroiled in The Wired have direct links to what they consider to be normality, leading to a possible multitude of selves. The death of Chisa – is it suicide, accident or murder? – is the catalyst for Lain's dive into this world, but does she really exist? If so, does she exist in a form that we consider to be human or does she reside merely in cyberspace (if that is the right term)? These questions affect not only the characters but also the viewers. Scenes can repeat or distort and whole plot elements can appear to deny possible changes to characters and events. Combining questions about humanity, the emergence of cyberculture and the combination of an apparently normal society with a new dominating technology, *Serial Experiments Lain* takes anime to a frightening but fascinating place with its complex plotting and manipulation of our expectations.

Jin-Roh: The Wolf Brigade (Jinrō [1999])

Directed by: Okiura Hiroyuki
Feature film, 102 mins

Jin-Roh: The Wolf Brigade takes a combination of subjects – alternate histories, terrorism and politics, as well as personal moral dilemmas – and places them into an anime that has a straightforward narrative but is imbued with reinterpretations of traditional fables. It is both artistically constructed and beautifully animated. Indeed, at times, *Jin-Roh*'s depiction of streets, crowds and the unusual

'camera angles' of its sewer-based settings are more reminiscent of live-action filmmaking. Partly this lies with the skill of the animation team in realising the design – there are virtually black-and-white photo-montage sequences and film 'scratches' on deliberately replayed sections – but perhaps it also relates to the screenplay, written by Oshii Mamoru, who had initially intended it to be a live-action film.

Alternative histories are an important sub-genre within anime – whether they represent new possibilities for the future, or explore a past that has different outcomes to actuality. *Jin-Roh* is set just over a decade after the end of the Second World War in a Japan that faces civil unrest. Centred on anti-government violence, the politicians decide that an additional security service, beyond standard policing, is required, and this takes the form of the Panzer Corps. Within the Panzer Corps, it is alleged, are elite operatives called the Wolf Brigade working undercover. Panzer Corps officer Fuse Kazuki has been taken off duty because he failed to shoot a young girl in a Tokyo sewer, something he should have done because she was involved with the militant anti-governmental group, the Sect. She was carrying a terrorist bomb, which she set off, narrowly avoiding killing him. Later, Fuse encounters Amemiya Kei, the girl's sister, and slowly begins a relationship with her. Matters become increasingly difficult for all as governmental concern about the Panzer Corps and political manoeuvrings seems to herald a change in roles and organisations. Fuse's personal and professional futures seem increasingly uncertain.

Oshii Mamoru's stories often link thematically, particularly in the way that both the characters and viewers perceive events as they unfold and how these link with the wider context of the narrative. These also include elements of human enhancement through technology which were explored in the *Ghost in the Shell* films, as well as in the live-action *Avalon* (2001), a film which bears some similarities to events in *Jin-Roh*. The title of the elite corps also links to the underlying theme, that of the wolf who is the central character in *Red Riding Hood* (Rotkäppchen), whose tale

(the Grimm one, not the sanitised fantasy children's story) is told as an allegory here. Technically *Jin-Roh: The Wolf Brigade* is superbly animated, particularly in the exactitude used when portraying the multitude of characters – not only in their features but in their lip-syncing and movement. It's a surprisingly emotional film, especially given its themes of militarism and terrorism.

FLCL (Furi Kuri [2000–01]*)*

Directed by: Tsurumaki Kazuya
OVA, 6 episodes

At the start of episode five, our protagonist, Naota, turns to face the viewer and asks, 'Do any of you guys have any idea what's going on?' And, to be fair, the only possible answer to this question is 'No'. Or, if you wished to provide a more detailed response, something along the lines of, 'No, but I'm *really* enjoying everything that I'm not understanding,' would suffice. But, fear not, all will become clear (sort of) by the end of this frenzied slice of utter madness.

Nandaba Naota's life is extremely boring. He lives in a small city that is overshadowed by a factory shaped like a giant steam iron. It even emits steam once a day. Still, things liven up a lot when Haruhara Haruko arrives in town with her wild pink hair and reckless attitude, even if she smashes into Naota with her vespa scooter and whacks him on the head with her bass guitar on their very first encounter. A bump developing on Naota's head is inevitable, although less predictable are the giant robots that will sporadically emerge from it some time later. Turns out that Haruko is an alien and she goes to live with Naota's family as the new housemaid. Naota is seriously unimpressed that his father seems to have the hots for their new resident. And his own future is likely to involve girls, guns, guitars, intergalactic relationships and, maybe, even alien pirate king Atomsk.

FLCL is an OVA from Gainax that comprises six fun-packed episodes combining high-school teen angst with manic aliens. Poor

Naota's world is turned upside down by the arrival of Haruko, a hyper, irresponsible extraterrestrial who is the very definition of hip. *FLCL* is chock full of references, not only to anime, but also Western animation (there's a nod to *South Park*) and even video game Trauma Center with its operating table science-fiction. Although *FLCL* was created as an anime, some episodes refer directly to a manga and we are shown post-post-modern comic-book images of the plot as it develops. The six episodes are self-contained yet wholly related so that any lack of understanding of the plot is both expected and unexpected and often emerges in a way that cannot be anticipated by the characters… or the viewer.

Frenzied, funny and zany, with a hugely enjoyable pop-rock sound-track and eye-popping visuals, *FLCL* is, admittedly, an anime aimed at those already versed in the culture, but all the more enjoyable for it.

Fruits Basket (2001)

Directed by: Akitaro Daichi
TV anime, 26 episodes

Poor Honda Tōru. Her mother died recently and she lost her home, but she's resourceful, if naive, and decides to live in a tent in the woods. Good luck strikes when the Sōma family chance upon her and offer her a room in their home, rent free, in exchange for her doing a spot of housework and preparing some meals for them. The household consists of novelist Shigure, and his cousins Kyō and Yuki, the latter of whom just happens to be the most desirable boy in her class (at least according to all the girls, and they should know). Now these rather handsome men have a family secret. They are each connected with a Chinese zodiac sign, which wouldn't normally be a problem, except that the family is cursed so that, whenever they are hugged by someone from the opposite gender, they temporarily turn into their respective creature. Can Tōru possibly balance school life, household duties, her part-time job, seeing her friends (the cool American Uotani Arisa and very slightly

disturbing Hanajima who senses other peoples' vibes), stop Kyō and Yuki from constantly fighting, and somehow keep the secret of the Sōma family, well, secret?

Based on the bestselling shōjo manga by Takaya Natsuki, *Fruits Basket* is a strange anime. It is faithful to its source, but was produced while the manga was still being written, and the story continued well beyond the end of the anime, so we are presented with only a part of the whole. That said, it's a good part, even if we do lose out on meeting some of the zodiac characters (the rest of the Sōma family live in a complex a short distance away) and the resolution is entirely different. Very typically shōjo, the male protagonists are, of course, eye candy but are also rounded-out characters and it's nice to see some alternative aspects of Japanese culture popping up as well. Tōru's mother was a bōsōzoku leader. In tune with the quirkiness of the plot many of the characters use a different form of language than would generally be expected of them: Tōru is actually a boy's name (indeed the Sōma family use Tōru-kun – an honorific generally used for boys – to address her) and Arisa uses gruff male vernacular to emphasise her status as a tough girl.

Tōru herself is a strange character – she's not terribly bright, almost nauseatingly dutiful, but is incredibly kind-hearted and has good spirit. She is connected to the story's title when she recalls the Fruits Basket game she played during her childhood – all her friends were assigned different fruit names but she was declared to be the onigiri (rice ball). The animation itself isn't up to much, as is the way with a lot of quickly (and cheaply) produced TV anime, but it does convey the sentiments and, surprisingly, some of the more emotional moments. Just be prepared to start bidding on Ebay for second-hand editions of the manga; new ones are so rare, they're like hens' teeth. Are there hens in the zodiac? Shouldn't that be roosters?

Hellsing (2001)

Directed by: Iida Umanosuke
TV anime, 13 episodes

As the title may suggest, this anime has a connection with Abraham Van Helsing, the famous slayer and general enemy of those of vampiric persuasion. The Hellsing Organisation, led by Abraham's heir, Integra, is patriotically affiliated to Her Majesty, Her Country and Her Church and aims to cleanse England of bloodsuckers. One particularly strong, charismatic and unique member of the Hellsing Organisation is the vampire Alucard (geddit?) who is a trusted servant to Integra. Alucard creates a new subject, nay servant, in the guise of 'police girl' Seras Victoria when he offers her his blood in order for her to survive a conflict with the ravenous undead. Victoria has to learn how to be a vampire, albeit a good one who doesn't sup upon the living but upholds the laws against the undead in this savage world. Times have changed since Bram Stoker's era as army helicopters, computers and phones are available to aid those who fight against supernatural adversaries. One such arch nemesis, among many, is Incognito, whose loathsome domination plans include the creation of modified freak vampires who are running amok throughout England's green and pleasant land.

In bringing vampire legends into the modern age, *Hellsing* manages to imbue its settings and backgrounds with strong respect for genre conventions (coffins for daytime repose, grand churches, etc) whilst embracing modernism with both its characters and technologies. Indeed, the evolution of the enemies' abilities means that the fierce and enigmatic Alucard has to wield an impressively designed handgun which he thoroughly enjoys using. As the battle between the factions intensifies, Victoria needs to learn to live as nosferatu even as she is coming to terms with her new abilities (strength, power) and weaknesses (intolerance of sunlight, need for blood). The relationships between those battling against the vampiric oppressors and their entourage of fearful beings creates much of the dramatic tension and the action is a strong element of the anime with its stream of massacres and copious bloodshed.

Other aspects of the modern approach to the vampire film emerge here, including clubs, gangsters and some of the more salacious elements of the genre, and the style reflects this, especially with

the music, which ranges from portentous orchestral music to rock and dance tracks. The animation is notable for its design aesthetic and the way that opponents (either good or evil) are destroyed – in flames, by dissection or explosion – as well as for the flowing hair, cackles of diabolical laughter, church imagery and vast array of flags and religious symbols. Bloody enjoyable horror anime whose success spawned additional OVA versions.

Other vampire anime can be found with the OVAs *Vampire Hunter D* (1985) and *Blood: The Last Vampire* (2000) and the TV series *Rosario + Vampire* (2008) and *Vampire Knight* (2008).

Metropolis (2001)

Directed by: Rintarō
Feature film, 113 mins

Welcome to Metropolis, a city-state that has seen many political and social changes in recent years. Robots have become an underclass because the public perceive them to be responsible for the current lack of employment, taking over the jobs of humans. The leader of Metropolis is Duke Red who has commissioned the construction of Ziggurat, a massive skyscraper which he believes will turn around the city's fortunes. He has also instigated the creation of a new type of android that has a particularly humanistic appearance: Tima will be central to the success of Ziggurat as its figurehead. However, Red's adoptive son, the violent gun-wielding Rock, has both a deep desire to destroy robots and astonishing android annihilation abilities, so he seeks to eliminate Tima. Meanwhile, spunky but less politically motivated Kenichi, the nephew of famous detective Shunsaku, is trying to follow the family tradition even if it involves perilous excursions into the less salubrious zones of Metropolis. Events lead him to encountering a strange young girl called Tima with whom he tries to form a friendship.

There are inevitably titular comparisons with Fritz Lang's huge-budget 1927 epic, but originally this version of *Metropolis* was a

manga by Tezuka Osamu, who did base his tale, and certainly its environment, on Lang's film. Despite notable plot differences, this modern anime, with a screenplay written by Ōtomo Katsuhiro, retains not only the robotic femme fatale of its forebear but also features politics, corporate entities and working-class insurgency amongst its themes. It discusses political, social, technological and relationship issues amidst a ripping tale of adventure and action spectacle – pure essence of entertainment. *Metropolis*'s artistic and directorial strengths allow for great set pieces as well as showing us the moral attitudes of the teenage protagonists adapting to a constantly changing society. Kenichi is a trusting boy, verging on naïve, who has a big heart and is determined to save Tima. Rock, on the other hand, violently despises anything robotic and destroys any that he feels are surpassing acceptable laws of existence. Both stand firmly by their beliefs and each is utterly convincing in their characterisation.

Both the design and the quality of the animation are superb. The mise-en-scene does recall Lang's film but the details – the advertising hoardings, the socially important Zones (which appear to be a nod to Tarkovsky's *Stalker* [1979]), the beautifully implemented weather conditions – create a world that is utterly believable. This is an example of anime at its finest – the story may be sci-fi pulp but, combined with the stunning artistic realisation, it becomes a thing of beauty.

Millennium Actress (Sennen Joyū [2001]*)*

Directed/written by: Satoshi Kon
Feature film, 87 mins

Millennium Actress is, quite simply, a love letter to Japanese cinema. The story is deceptively simple but that is its strength. Genya (Izuka Shōzō) wants to make a film about the life and career of veteran actress Fujiwara Chiyoko (Shōji Miyoko, Koyama Mami and Orikasa Fumiko), despite the fact that the star has withdrawn from society and is more concerned with distinctly quaffable herbal

teas these days. But she agrees to an interview and so begins the story of her acting career and, more importantly, her long-lost love. The key to this, if you will, takes the form of a key, that Genya presents to his subject and which triggers a series of recollections, that may or may not be entirely true but nevertheless take into account both Japanese film history, Japan's history as portrayed on film and Chiyo's paramour, a revolutionary and artist, whom she encountered as a teenager.

Chiyoko is not based upon a particular actress but it is impossible not to draw comparisons with a number of classic Japanese characters and films. There are memories that recall the works of Ozu Yasujirō or Naruse Mikio. Maybe it is Hara Setsuko who is the main inspiration. She starred in Kurosawa's *No Regrets for Our Youth* (*Waga seishun ni kuinashi* [1946]) and *The Idiot* (*Hakuchi* [1951]) as well as Ozu's 'Noriko Trilogy', a series of films whose lead character is called Noriko (although the films are individual stories). The best known of these is the critics' darling *Tokyo Story* (*Tokyo Monogotari* [1953]), but the other two films, *Late Spring* (*Banshun* [1949]) and *Early Summer* (*Bakushū* [1951]) perhaps give a better indication of the character as portrayed in *Millennium Actress* – a cheerful but gentle single lady who takes her responsibilities seriously. There are other references too: the witch character with her spinning wheel, played by Chiyo's 'rival' actress, is straight from Kurosawa's *Throne of Blood* (*Kumonosu-jō* [1957]) and in some respects the film also recalls Stanley Kwan's Chinese live-action film, *Centre Stage* (1992), a tribute to a specific actress – Ruan Lingyu. However, Kon Satoshi places his anime in an environment that does not have the restrictions that a live-action film would encounter, and allows the present and the past to be 'filmed' in a way that means the camera (as such) can dissolve between compositional shots that delineate eras and characters with seamless integration within the story.

Despite the similar themes, this is a complete contrast to Kon's debut, *Perfect Blue*, which explored the deteriorating psyche of an idoru (pop idol) turned actress. *Millennium Actress* is as much about film and society's association with the past and the present

as it is about its central characters, the titular Chiyoko and the documentary filmmaker Genya. The film shows us recollections of what they perceive to be a golden past that cannot be regained. A moving story of age, love, relationships and, above all, cinema, *Millennium Actress* is as emotional as it is historical.

Spirited Away (Sen to Chihiro no kamikakushi [2001]*)*

Directed by: Miyazaki Hayao
Feature film, 123 mins

Chihiro is moving home with her parents and, on the way to their new house, the family stop off at what appears to be a disused theme park. The place seems to be deserted but Chihiro's hungry parents come across a marvellous feast and tuck right in. Chihiro leaves them to their gorging and meets Haku, a handsome boy who warns her that she must leave before nightfall. But when Chihiro returns to her parents, she finds that they have been transformed into obese swine. She is trapped in a cruel and frightening place that is filled with spirits and supernatural creatures, ruled over by the diminutive and menacing sorceress, Yubāba, who renames her and demands that she perform the world's most disgusting chores. Will she remain trapped within this nightmarish situation, and how can she possibly rescue her parents?

Although many people in the West were aware of anime, they often had various preconceptions connected with otaku/fan culture or had heard stories that anime was incredibly violent or pornographic, so *Spirited Away* was their first mainstream introduction to the format. The film's success was entirely justified. It is a masterpiece of cinema, but perhaps a little surprising for, despite its sense of wonder, *Spirited Away* is a rather melancholy film. Amidst Miyazaki's wonderfully realised fantasy world, with its strange and interesting creatures, the sense of menace is palpable and Chihiro's predicament utterly terrifying. Chihiro adapts quickly to her circumstances and remains brave and determined, despite

facing a horrifying foe. Yubāba maintains her power by taking people's names; Chihiro is renamed Sen, and Yubāba's possession of her name means that Chihiro's very identity begins to fade.

Miyazaki's imagination is given full rein in this film, as evidenced by the astonishing array of creatures that populate the world. Almost all the residents have multiple forms and shapes, from the revolting stink spirit, whose disgustingly smelly bath Chihiro has to clean, to her new friend, Haku, who will assist her in any way he can. Chihiro survives in this macabre land because she treats everyone she encounters with respect. Miyazaki's direction is confident and assured, as befits a master who has spent decades honing his craft.

Chobits (2002)

Directed by: Asaka Morio
TV anime, 24 episodes

Motosuwa Hideki has big plans for his future – to leave his rural home and live in Tokyo, get himself an education (he has to go to cram school to get into university) and enjoy whatever opportunities city life will offer him. He finds accommodation in Hibiya-san's apartment block and becomes good friends with neighbour, and fellow student, Shinbo Hiromu. He'd also rather like to own a Persocom, an expensive, electronic, virtually human-looking machine. And, as luck would have it, Hideki chances upon an outrageously cute one in a pile of rubbish. He thinks she may be faulty as she has clearly been chucked away and can only say 'Chi', but he adopts her anyway. His knowledge is deeply limited so he turns to Shinbo and his own Persocom, the super-enthusiastic, super-teeny Sumomo, and youthful computer geek, Kokubunji Minoru, who owns an outrageously large collection of distinctly provocative-looking Persocoms himself. They consider the possibility that Chi, who slowly develops knowledge, vocabulary and even gets a job in a cake shop, may be one of the Chobits – legendary and misunderstood experimental Persocoms. And there

are others looking for her too. Hideki, meanwhile, has a multitude of problems: his studies (he fancies his teacher), his job at a restaurant (he fancies the girl who works there), his virginity (not aided by Chi telling all his visitors about his 'yummy' magazines), and his complete misunderstanding of city life. And then there's Chi: what was her past and what is her future? What are the chances that Chi and Hideki can just have a nice relationship that involves hugs without leads, power, networks, cables and social misunderstandings?

The joy of *Chobits* initially lies with the humour of watching a country boy adjusting to city life whilst trying to teach a robot the ways of the world. The Persocoms are ostensibly a consumerist fashion accessory, call them the iRobot if you wish, but Hideki trying to forge a relationship with Chi while studying, working and maintaining his friendships is what holds the series together. The broader story explores personal and Persocom relationships, the greater context of the Chobits machines (what they are, how many there might be, if they exist at all) and the increasing use, and indeed abuse, of Persocoms within society. Originally published in weekly *Young Magazine* by the Clamp collective, *Chobits* is a humorous drama which also asks questions about our modern age and its relationships with technology. Fun with depth, Chobits want to be with you.

Naruto/Naruto:Shippūden (2002/07–)

Directed by: Date Hayato
TV anime, ongoing

Uzumaki Naruto has more problems than most twelve-year-olds. For a start, his parents died when he was born, he doesn't really pay much attention in school, and there's a hideous demon fox that attacked his village, Konohagakure, sealed inside his tummy. Naruto is from a ninja village and is convinced that his skills will eventually lead to him becoming Hokage, the village leader. But, despite his enthusiasm, he really is the village's Number One

Knucklehead Ninja. Class dunce Naruto teams up with class genius Uchiha Sasuke, who has his own issues, and Haruno Sakura, who is totally in luuuurve with Sasuke. With the guidance of their highly skilled and slightly perverted master, Hatake Kakashi, they seek to become splendid ninja by carrying out missions on behalf of their village. Joining them are a whole bunch of ninja rookies who are all ready to face any foe threatening not only Konohagakure but the wider world.

The continued popularity of *Naruto*, not only in Japan but worldwide, has ensured that it has become a cultural phenomenon. It is the combination of adventure, conflict and comedy that makes the story so engaging and downright enjoyable. All the characters in *Naruto* are clearly individual and this is part of the story's impetuous charm. Naruto himself is a cheeky scamp, initially utterly hopeless but with a blinding belief in his own abilities. His main attribute is that he is utterly determined to achieve his dream and will never give up. His rival, Sasuke, is his opposite, a dark brooding genius. Both have had traumatic pasts, but their approach to life is completely different and their development as ninja take very different paths.

Naruto: Shippūden follows a few years after the conclusion of the first series where the characters have altered their allegiances significantly to allow for further conflict. If individual rivalries are seen as mere teenage strife in *Naruto* then these conflicts are more clearly defined in *Shippūden* and become significantly darker, developing from a rivalry between comrades: Sasuke's deep distrust of Naruto and his clear motivation towards evil dominance, while our plucky hero still believes he can save his rival.

The series is still ongoing at the time of writing, with the manga becoming increasingly convoluted and no end in sight. Because the manga is still ongoing, the anime not only keeps up with the episodes but occasionally overtakes the main storyline, so *Naruto* is particularly susceptible to 'filler' episodes which don't actually further the plot. Indeed, there were whole series of fillers between the end of *Naruto* and the start of *Shippūden*. You have been warned...

Tokyo Godfathers (2003)

Directed/written by: Kon Satoshi
Feature film, 92 mins

It's Christmas Eve and, although it seems an appropriate time of year to celebrate the birth of a newly born child, Gin, Hana and Miyuki are three homeless individuals who discover an abandoned baby girl, Kiyoko, whilst seeking food among the garbage. The three are neither wise nor all men but they endeavour to do their best with the discovery, even if their own understanding of child-rearing is as limited as their resources; they desperately need to find food and shelter. With New Year approaching, and with Tokyo embroiled in celebrations and unconcerned about the thoughts and desires of these very different people and their newly discovered infant, the three endeavour to find Kiyoko's parents.

Set around Christmas and the New Year, with hymns providing a choral backdrop, *Tokyo Godfathers* is, at times, an upward-looking film that integrates all of humanity in its attempts at understanding the world. Our three central characters – 'a bum, a homo and a runaway' – are as unlikely a trio of lead protagonists as you will see in cinema, let alone anime. Gin is an ageing alcoholic who feels he failed his wife and daughter, Hana is a cranky and irritable transsexual with health issues, and Miyuki a young homeless girl who has run away from her family. Kiyoko, but days old, is the link that provides them with the means of coming to terms with their troubled pasts and, inadvertently, a future that may be brighter. *Tokyo Godfathers* doesn't provoke unnecessarily optimistic outcomes but instead portrays the humanity of its protagonists in a way that is heart-warming and occasionally bittersweet. This is further emphasised by the animation itself, which places the sometimes deliberately accentuated characterisation within a clearly defined, realistic Tokyo setting.

Co-written by Kon and Nobumoto Keiko (whose writing talents were also responsible for *Wolf's Rain* and *Cowboy Bebop*), *Tokyo*

Godfathers is a genuinely moving and emotional contemporary drama. A closely observed character piece that shows three vulnerable, flawed individuals trying to seek responsibility and redemption in an unfair world, it demonstrates anime's storytelling capabilities at their finest. It also features a fine electronic rendition of Beethoven's *Ode to Joy* that rivals that in *A Clockwork Orange* (1971).

Wolf's Rain (2003)

Directed by: Okamura Tensai
TV anime, 26 episodes

Paradise lost or paradise hound? There is a legend that states that when the world ends, Paradise will open, but only the wolves will know how to find it. Although some human societies are aware of the existence of Paradise, predominantly it lies in the domain of the wolves, but they have been virtually wiped out or forced into slavery. Capable of appearing in human form, the survivors are from packs which have been obliterated: some are lost and alone, others motivated to achieve their purpose. Kiba is one such wolf. Injured and seeking the companionship he does not even realise he needs, he faces similar dilemmas to other wolves he chances upon in the grim city: gruff Tsume, affable Hige and young runt Toboe. The four join up and head to Freeze City, drawn by the scent of the Lunar Flower, which they assume will lead them to the Flower Maiden who will be able to guide them on their journey. She is Cheza, created by the clan of Lord Darcia, who has his own nefarious plans involving the future of the Flower Maiden, the wolves and Paradise. So a journey of direction, misdirection, trust, betrayal and fear ensues as the wolves seek to reach their final destination.

Wolf's Rain is a fantasy drama that may take a while to engage with initially because of the plethora of characters (some of whom will not appear in the later story) that it introduces right at the start, but, once it has settled into its stride, it makes for compelling viewing. It is only after events have unravelled halfway through

the series, and been presented to us again, that we reaffirm our emotional understanding of the characters and this strengthens our connection with them. The canine protagonists are depicted in wolf and human form, and occasionally the sharp visual cuts between the two accentuate the more savage elements of the wolves' nature. They serve as a constant reminder that, no matter how human the wolves appear to be, and how human their emotions, they are not accepted in this world and often have to resort to brutal means simply to survive. But what really holds the series together is the way the main group's spirit and determination leads to a fragile companionship that feels utterly realistic in its portrayal. At times you feel the elation of the wolves, after joining up with Cheza, as they bathe in the light of the full moon, or wince at the pain of yet another violent confrontation with those who seek to destroy them. It's a complex and intelligent fantasy series that also has a true sense of authenticity in its uncertainty as to the ultimate fate of its central characters. The result is a deeply affecting story.

Elfen Lied (2004)

Directed by: Kanbe Mamoru
TV anime, 13 episodes

The world can be a daunting place and human beings have a code which defines acceptable behaviour, as well as prejudices based upon visual appearances, especially against those who don't quite seem 'normal'. Lucy looks like an ordinary young woman but possesses two small horns on her head. She is a Diclonius, predominantly human, but with significant genetic differences. The population of Diclonii is increasing and they are either quarantined in a secret institution or slaughtered by the authorities. Lucy escapes captivity using her powers – almost transparent hands that emerge from her insides like spiritual tentacles – powers that can inflict extreme destruction upon her captors, pulling apart appendages and spraying fountains of blood. After she slaughters a team of gun-

wielding soldiers she leaps into the sea, eventually washing up onto the shore at Kamakura. Taken in by cousins Kōta and Yuka, who are residing in a large building owned by Yuka's family, it appears that Lucy has forgotten much of her former life, abilities and language skills and becomes known by her only vocal utterance, the emotionally varied use of the word 'Nyū'. Matters take a multitude of problematic directions as Kōta and Yuka try to help and understand Nyū, befriend homeless girl Mayu and her stray dog Wanta, and continue their studies at university. Meanwhile, those who had incarcerated Lucy are still searching for her and will use any form of weaponry to destroy her, whatever the bloodthirsty results, especially if she were to re-emerge as her former self.

Based on the seinen manga published in *Young Jump*, *Elfen Lied* is almost like a violent *Chobits*, combining a number of genres – science-fiction, burgeoning romance, family drama – that would initially seem to be an unlikely mix. However, the story is well constructed and reveals its secrets in a convincing way. It is by no means an easy watch – themes of abuse and loss lie at the heart of *Elfen Lied*'s narrative. But, despite depicting difficult issues and extreme violence, it doesn't obsess over these, even if these scenes are occasionally long and graphic – limbs are strewn, bodies dissected in torrents of gore, and the plight of a central character's past revealed as horrendous sexual abuse, degradation and humiliation instigated by her stepfather. These contrast strongly with Kōta and Yuka's compassion in taking in strays, and their attempts at creating a stable family for those who end up living with them, as well as discovering long-held feelings for each other.

Harsh but engrossing art drama, as indicated by the title sequence that reflects the series' theme – a gothic story revealed through Latin choral music and Klimt-enhanced illustrations – *Elfen Lied* is not an easy watch but, in the end, it is both savage and moving.

Paranoia Agent (Mōsō Dairinin [2004]*)*

Directed by: Kon Satoshi
TV anime, 13 episodes

Designer Sagi Tsukiko is having a bad time. Everything in her life should be wonderful; after all, her character Maromi, a pink 'n' cuddly cartoon dog, is proving to be hugely successful. But Tsukiko is feeling the pressure because her firm wants her to create more marketable characters for them. Things get worse when she ends up being savagely attacked by a mocking, youthful, roller-skating hoodlum wielding a baseball bat. Initially her recollection of the attack is viewed with doubt but it soon becomes clear that a brutal assailant, known in the media as Shōnen Batto (Lil' Slugger), is on the loose, ready to attack anyone who has any doubts about anything. Detectives Keiichi and Maniwa are on the case.

Paranoia Agent's basic premise initially appears to be that of a crime drama with a mystery attacker, albeit one that asks questions about societal decline. But the series is more concerned with the depth of not only the characters and their involvement in this street violence, but also the interpretation of these events in the media. At the outset we are given a glimpse into the lives and stories of many of the characters but, as the plot progresses, the revelations of their pasts and their present attitudes become increasingly varied in tone and definition. Apparently minor characters may or may not become intrinsic to the unravelling of the story. This is a truly post-modern anime that not only questions its plot and motivations but also itself as a form of entertainment. There are a great deal of references to anime culture and its creation. The relationship between reality and the media is seen as indefinable, with superheroes, role-playing, arcade games and personal drama integrated as elements of normality within the plot. One character becomes a sword-wielding hero, balancing his ideals with otaku-gaming, geeky wish-fulfilment. Within the genre-enhanced stories there are a number of issues – from media manipulation and creation (including news shows, as

well as the self-referential production of anime) to social issues such as pornography, idoru adoration and suicide pacts. This is a world where the demons are both frighteningly normal and distressingly supernatural.

Paranoia Agent is a superbly constructed series that uses a variety of styles to develop its increasingly multi-media-enhanced plot lines. Within a perceived reality we confront crime, supernatural and kaiju genres (amongst many others) as part of the plotting. If the focus lies with the brutality and shocking abilities of Shōnen Batto, this character is merely a MacGuffin, there to direct the viewer towards what appears to be a detective narrative when in actuality it is a compelling melange of art, drama and social commentary that, like life, amalgamates humour and sadness, fear and courage, despair and hope.

The Place Promised in Our Early Days
(Kumo no Mukō, Yakusoku no Basho [2004]*)*

Directed/written by: Shinkai Makoto
Feature film, 91 mins

People often look back upon their school days with rose-tinted spectacles, but actuality rarely matches the simple joy of growing up that is portrayed in films. Takuya and Hiroki are school friends who live at the northernmost point of Japan's main island. They are fascinated by the mysterious, impossibly tall, thin tower that has an undetermined scientific purpose, built on Ezo, the island formerly known as Hokkaido, and inaccessible since the island's separation from mainland Japan. They have a dream to build an aeroplane together and fly across the sea to discover the tower's secrets. And they promise to take their friend, Sawatari Sayuri, with them. However, before they realise their ambition, Sayuri mysteriously disappears. Some years later, the boys have grown apart and their careers have taken very different directions. And Sayuri is in hospital, having succumbed to a strange disease that

seems to have left her in a multi-world, multi-dream, multi-outcome coma state. Worse, she is key to preventing the tower, which is actually a weapon, from activating and destroying the world.

As a gentle, character-based drama set in an alternate world, *The Place Promised in Our Early Days* excels in a number of ways. Its main strength lies in the way that it takes on the themes of a coming-of-age drama, but places them in a genre environment. We are introduced to a Japan that is strangely familiar and yet very different – a parallel universe where Hokkaido is politically separated from Honshu, with the mystery of the tower that draws the friends towards their adventure.

If the premise initially seems confrontational, and vaguely political, this is addressed by the strength of the friends' relationships and their ambitions. Building an aircraft will not only develop their mechanical skills but also allow them to transport themselves to the tower, which represents something unattainable to them. Even as their worlds grow apart they remain linked to the comatose Sayuri, together with her desire to see the world beyond the tower.

It is the personal relationships and character interaction that make the film so interesting on an emotional level, enhanced by the excellent animation, which turns the strangeness of the parallel world into an easily perceived normality and makes the scientific and psychological revelations all the more believable. These relationships give the fantasy elements credibility and so the audience relates to the central characters and their issues, along with an entirely realistic society, with its corporate, government, militaristic and working-class elements.

Steamboy (2004)

Directed by/written by: Ōtomo Katsuhiro
Feature film, 126 mins

In an alternative Victorian England, preparations are underway for the 1866 Great Exhibition, with dignitaries from all over the world due to be present in London. Young, Manchester-based inventor

James Ray Steam is an engineering whiz kid who takes after both his grandfather, Lloyd, and his father, Edward, so is fascinated to receive a mysterious ball from his grandfather with direct instructions not to let 'The Foundation' take it from him. Which, of course, is just what this mysterious organisation attempts to do. Fortunately, with aid of his steam-powered monowheel, James escapes pursuit and even manages to run into the intended recipient of the ball, Robert Stephenson, on a passing train. Sadly, an airship attack seizes James and his ball and he finds himself in London, in the company of the Foundation's stroppy rich-girl, Scarlett O'Hara St Jones. And he also gets to meet both his father and grandfather, although they are now on opposing sides – and have completely different beliefs regarding the use of their technological innovations.

Steamboy combines all the elements that make for a thrilling adventure and a celebration of engineering, setting the story in an alternative past, contrasting the familiar backgrounds and settings with astonishing inventions that are as exciting to the viewer as to the characters. The film seamlessly integrates real historical characters and events with fantastical machinery to create a steampunk perspective on proceedings. It explores the philosophy of technology and the way it can be used for evil as well as beneficial means. In addition, Ōtomo creates fantastical or magical elements in this mêlée of technological advances, turning ice and water into something both terrifying and beautiful.

In terms of technical execution, *Steamboy* excels not only with its use of cel animation but also the manner it uses CG technology to accentuate its artistic vision in a way that is so subtle as to be indistinguishable. The artistic reconstruction of Victorian England is designed with a wonderful attention to detail. Unsurprisingly, *Steamboy*'s budget was immense and its production time lengthy, but the results of these efforts are there for all to see. Despite this, the film was not a huge success at the box office, only just reaching inside the top 50 on its year of release, well behind many anime such as *Howl's Moving Castle*, as well as *Pokemon*, *Doraemon* and *Detective Conan* big-screen features.

It's a beautifully designed, beautifully constructed adventure that shows the real possibilities of artistic animation. And without giving away too much of the ending, Ōtomo Katsuhiro manages to destroy large parts of another capital city. Not a Tokyo of the future this time, but a London of the past.

Final Fantasy VII: Advent Children (2005)

Directed by: Nomura Tetsuya
Feature film, 126 mins (Director's Cut)

Although the Western understanding of anime centres around traditional, cel-based, stop-motion animation, elements of computer-based (CGI) animation have been incorporated into animated, as well as live-action, film in varying degrees for decades. *Final Fantasy VII: Advent Children* brings a distinctly anime style to the CGI format and, while it takes a marvellous approach to its design, using a multitude of angles and perspectives, its narrative, characterisation, visual and aural influences can clearly be found in both traditional anime and the video-game industry. *Final Fantasy VII*'s backdrop comes from the series of role-playing video games of the same name. However, while the gaming aspects are present onscreen, there's also a demonstrable appreciation for traditional cel animation styles. Point-of-view shots, cameras moving in three dimensions, and a variety of angles that would be prohibitively time consuming to integrate into a cel-based production are shown in their full in CGI glory, as are tricky elements like the individual hairs atop characters' heads wafting impressively in the breeze and masses of crowds reacting to onscreen events. These are contrasted with occasional instances where traditional animation styles are deliberately acknowledged: the sometime use of static backgrounds, elements of anime character design – such as manga-style, spiked hair which doesn't waft in the breeze, impressively or otherwise – and some consciously two-dimensional panning.

Our spikey-coiffured hero, Cloud, is living life on the edge, the city of Edge that is, where he and Tifa are looking after two

children, Marlene and Denzel. Times are traumatic as an imminent apocalypse seems, well, imminent, in the form of the disease Geostigma, which is affecting a large proportion of the populace and for which there is no known cure. If that were not enough, there are issues concerning the whereabouts of Jenova, an alien life-form whose existence may have resulted in the creation of Sephiroth, Cloud's enemy, whom he has already defeated. But Kadaj, Loz and Yazoo wish to find Jenova's head and resurrect Sephiroth. Any resolution will inevitably involve conflict, confusion and contagion.

Angels and demons, spirituality and military, ancient and modern combine to ensure that *Advent Children* embraces a number of contrasting themes within its running time. The soundtrack includes choral and metal elements, as well as pop and synthesiser music, and cuts easily between these styles to suit the plethora of events that include spiritual encounters, disease and the decay of society. The apocalypse is a theme that is common in anime and the prospect of any character from any side fulfilling a destiny by the film's close is often limited. Characters can just as easily become dust or demons, angels or martyrs.

A visually stunning, mixed blend of anime conventions integrated into a CGI format that embraces its technological possibilities, *Advent Children* also recognises its origins (Final Fantasy I was released in 1987 on the 8-bit Famicom) to create hi-tech graphics with a traditional twist.

Stormy Night (Arashi no Yoru ni [2005])

Directed by: Sugii Gisaburō
Feature film, 105 mins

It was a dark and stormy night (although not quite as written by Snoopy), and young goat, Mei, is forced to find shelter in a cabin. Soon he is joined by Gabu and the pair spend the night in their shared accommodation, the darkness preventing them from actually

seeing each other, while they have a conversation about their fear of thunder. They agree to meet again after the weather has improved, recognising the other by using their special password, 'stormy night'. There is a slight issue in that Gabu is not a goat. He is, in fact, a wolf, and wolves like goats. They derive great gastronomic pleasure from devouring them savagely. But, wouldn't you know, the pair meet up and become the best of friends, walking together and enjoying the wonderful environment, seeking places to eat food together (though in Gabu's case this really shouldn't involve his rather tasty looking buddy). The problem is that their tribes and their species do not understand their special friendship and would do anything to curtail it. Gabu's bunch seek Mei for lunch… and the rest of the goat tribe too.

Stormy Night is adapted from the books by Kimura Yūichi and, in many ways, appears to be like a Disney film on the surface. It is for children and, although there are elements of a scary nature, this is primarily a story about an unusual friendship that is maintained whatever the cost, either to the protagonists or their wider communities. Indeed, the relationships between food and dinner are what mark the film's strong characterisation and elicit moments of genuine emotional response from the audience. We understand Gabu's desire to eat his friend in a way that is initially comic but becomes very moving when this plot device touches on self-sacrifice.

The animation is exemplary throughout and the primary characters are perfectly designed and developed as distinctive individuals who, vitally, retain a sense of natural-world realism. This doesn't apply only to the protagonists, Mei and Gabu, but extends to their tribes, including the ancient grandmother goat and the scar-faced, savage-mouthed meanness of the wolves, as well as the other animals that reside in the world. With artistically realised animation design and a timeless musical score, its adventure-story elements mixed with genuine questions about individuality, morality and societal obligations, *Stormy Night* enjoyed a deserved success upon its release.

Death Note (2006)

Directed by: Tetsurō Araki
TV anime, 37 episodes

When Yagami Raito (Light) finds a notebook on the ground, he has no idea that it is, in fact, a Death Note, accidentally dropped by Shinigami (god of death) Ryūku, which can cause the swift demise, either by heart attack or user-defined methods, of any person whose name the current owner writes within. After confirming it is correct in its murderous capabilities, Light uses the Death Note to create what he hopes will be a crime-free society by killing off known criminals. Light becomes known in the media as Kira (aka Killer) for the increasing number of deaths that he is causing, resulting in both moral and legal ramifications. A distinctly capable but unusually young and misanthropic detective known as L is brought in to investigate.

Originally produced as a manga in *Weekly Shōnen Jump*, Ōba Tsugumi's *Death Note* became enormously popular. The anime, which comprised 37 episodes that concluded within a year of its first broadcast, is both plot- and character-driven and is thoroughly absorbing. A number of live-action versions were also produced but they necessarily reduced some plot strands and characterisation as a necessity of feature film running-time restrictions.

Death Note is a compelling anime series that asks clearly defined philosophical, social, moral and legal questions in a fantasy context. But it is the characters and their interactions that engage as much as the fantastical elements, not only with the central character of Light (who sets up the premise when he finds the Death Note and interacts with the Shinigami), but also the mysterious L who becomes just as relevant as events progress. The rivalry between the pair of geniuses, as each tries to outwit the other (even though L is at a distinct disadvantage, not knowing Kira's identity), is what drives the story, although supporting characters such as Misa – whose role becomes repeatedly modified from pop-idol model to

victim to oppressor to co-conspirator – add to the intensity and depth of the plot. As events progress, the story becomes increasingly complex; this is the product of an Internet, social-networking and corporate-media-controlled world that seems all too familiar.

The animation itself is not of the greatest quality, although the sound (and soundtrack) are constantly engaging. But *Death Note*'s trump card is that it utilises its plot and fascinating characters to hold viewer interest as well as raising issues about criminality, media, celebrity culture, commercialism and societal expectation within a fantasy context where demons and criminal activities affect the media-saturated youth, driving their moralistic outlooks and aspirations.

Ouran High-school Host Club
(Ōran Kōkō Hosuto Kurab [2006]*)*

Directed by: Takuya Igarashi
TV anime, 26 episodes

A respected school for the elite, Ouran High School has a number of student societies but none more refined and elegant than the Host Club. There's a host for everyone: blithe, carefree and occasionally melodramatic president, Tamaki; serious vice-president, Kyōya; the naughty twins, Kaoru and Hikaru, along with cutesy, Honey, and his strong, silent companion, Mori, who barely utters more than an affirmative grunt during each episode. Between them, they can satisfy the needs of all their adoring female clients, who squeal 'moe!' (an expression of delight) with relish at every opportunity. The club exists for the school's handsomest boys with too much time on their hands to entertain young ladies who also have too much time on their hands. Haruhi is not a young lady with too much time on her hands. She has fulfilled the academic requirements to study at the school but is there purely on academic merit and is virtually penniless. When she stumbles upon the Host Club and accidentally breaks a very expensive vase, she is obliged to join the

club (as a 'male' host, of course) to repay her debt. It turns out that Haruhi has a better understanding of girly desires than many of her fellow club members, so is hugely popular amongst the clientele. What is a girl supposed to do in such an environment, whilst still getting the education she desires?

Fine shōjo anime, *Ouran High School Host Club* is quite simply delightfully debauched decadence. Host clubs are a feature of the night-time entertainment industry in Japan, places where clients are entertained with drinks and conversation. These used to revolve around primarily female staff catering to men, but male host clubs have become increasingly common in recent years. *Ouran High School Host Club* takes this concept as its primary theme and creates a reverse-harem series that is light and fluffy, with very little subtext, aiming to be all kinds of fun. The boys are gorgeous, of course, and you get a fair representation of some typical bishōnen archetypes, including the prince (Tamaki), the megane (glasses wearer, Kyōya) and the loli-shōta (Honey, who loves teddy bears and cake, despite being the oldest member of the group). But down-to-earth Haruhi is clever, amiable and unpretentious, and all the hosts adore her (especially Tamaki), as do the elite female clients, who squeal with glee as she manages to shock them with her proletariat instant coffee and occasional trips to the supermarket to grab a bargain.

This thoroughly enjoyable series includes elements of self-parody and a number of referential moments when the characters reveal themselves to be part of an ongoing anime that you, the viewer, is watching. With cross dressing and just a hint of 'twincest' for any fangirls, all wrapped up in a class-based situation comedy, this series has a lot of heart. Moe!

Strawberry Panic (2006)

Directed by: Sakoi Masayuki
TV anime, 26 episodes

An example of yuri anime, *Strawberry Panic* is a delightful, single-sex-school-based drama. Yuri, which can be translated as lily, is the

generic term related to lesbian-based media. *Strawberry Panic* is based upon the work written by bishōjo writer Kimino Sakurako. Bishōjo are cute young girls and this is clearly evidenced by the lack of men and very few characters older than 20 in this anime.

Aoi Nagisa is a transfer student, starting her fourth year at Miator, one of the schools at Astraea Hill. Unfortunately, her first three years were spent elsewhere so she is a newcomer and has a lot to learn about this educational establishment. She shares a room with Suzumi Tamao, who instantly adores her and is super-keen to introduce her to the school and her fellow pupils. Nagisa quickly adapts to school life, making new friends both in Miator and in the other schools, Spica and Le Rim, as well as learning about the customs and etiquette of this unusual establishment. But Nagisa is most intrigued by the person she first met upon her arrival at her new school. For, in the nearby forest, she engaged in a hypnotic encounter with a mysterious young woman – could she be spirit or seductress? It was actually Hanazono Shizuma, the school's Etoile (effectively the head girl), who was similarly captivated by Nagisa. But, although Shizuma is beautiful, confident and respected by the whole school, maybe there are issues from her past that need to be resolved.

Friendships and relationships are essential to the progression of *Strawberry Panic*'s story, along with the gentle rivalry between the three schools and the election of next year's Etoile, all of which form major plot strands. As well as the potential relationship between Nagisa and Shizuma, we are also introduced to Amane, the school's boyish equestrian star, and shown her encounter with shy young chorister Hikari, as well as the unrequited love that Hikari's room-mate Yaya has for her.

The animation by Madhouse is well constructed, particularly for TV anime, and exquisitely designed, especially the impressive, European-inspired architecture and Catholic church settings. But what makes *Strawberry Panic* really work is the way that it depicts many elements of life in a girls' school. Much of it is hugely romanticised, but it captures some of the cattiness and politics that make the story feel more convincing. But this is far more

than public-school St Trinians or Malory Towers; it has elements that occasionally verge on the Bronte-esque, as the Etoile's past is revealed to be verging on gothic tragedy. There are brief scenes of nudity during some of the romantic encounters.

With a heavy dose of sugar, spice and all things nice, *Strawberry Panic* is a delightful anime that will genuinely lift your spirits.

xxxHolic (2006)

Directed by: Mizushima Tsutomu
TV anime, 24 episodes

Watanuki has a strange ability – he can see yōkai, spirits that are, to the rest of the world, apparently invisible. This skill is something that he finds to be terribly annoying and his interactions with the spirits usually end in trouble. He chances upon a shop run by the beautiful and enigmatic Yūko, who informs him that it is inevitable that he should find her. The shop grants wishes and, in exchange for his desire to be rid of the spirits, he starts working there as an assistant. The shop's esoteric products are both fascinating and arcane. Watanuki is occasionally required to engage in salesmanship but is more likely to be found working in the kitchen, supplying alcoholic beverages for his employer to sup upon or creating a variety of meals. Good thing he's a jolly good cook. But he cannot escape the supernatural world entirely and, thanks to Yūko and his high-school companions, Kunogi Himawari (whom he adores) and Dōmeki Shizuka (whom he detests), his life becomes both fascinating and occasionally bizarre.

Despite its title, *xxxHolic* is not about an addiction to salacious material (it's pronounced 'Holic') but rather a lovely and beautifully designed story, based on the manga by Clamp, showing a young man's encounters with the spooky spiritual world. Its main protagonist is initially placed in the more familiar context of high-school and teenage confusion, allowing the viewer more easily to engage with the esoteric elements of his life, combining the sublime, ridiculous, real and spiritual – with laughs and scares

aplenty. And, as long as there is adequate business and Yūko gets a tipple, hopefully all should turn out well...

One notable aspect of *xxxHolic* is the strong use of design and artwork. The Art Nouveau style (Clamp's Mokona is apparently a fan of Alphonse Mucha) is apparent not only in the character design, including the long, bendy limbs of Watanuki and the almost classical decadence of Yūko and her costuming, but also the way that the spiritual and corporeal world are portrayed. The TV series ran for 24 episodes, the last one of which, effectively a coda in the form of a flashback, was sweet and sad, a fitting end to this charming supernatural drama.

Baccano! (2007)

Directed by: Takahiro Omori
TV anime, 16 episodes

It's all aboard the Flying Pussyfoot, a train that traverses the American continent, but many of its passengers are gang members or assassins. Violent confrontations are inevitable. In New York the mafia is throwing its collective weight about and crime-related violence is prevalent, even for petty thieves. And this is only when you consider the 1930s. These proceedings are also inextricably connected with events in the eighteenth century and the beginning of the twenty-first, when many of the characters are still alive. What has this to do with a mysterious alchemic elixir?

Multiple characters, multiple time strands and multiple plots reveal tales that are distinctly separate but yet interweave, where good and evil are as ill-defined as the concept of mortality to some, in a world that feels familiar but is not. Individuals are not who they seem, even to each other, thanks to a secret panacea, the effects of which only become clear later in the series. *Baccano!* works on a number of different levels although aspects of the plot can initially seem imprecise or unclear. However, this is an intrinsic part of the series' structure and vital to the way that events are portrayed, as

individual moments are but indefinable fractions of the protagonists' lengthy and varied lives. Partly this is down to the source of the anime – a series of light novels by Narita Ryōgo – but is also inherent in the way events of the past and present affect the main time period in which much of the story is set. *Baccano!* does not have a distinct plot based upon a small series of central characters but rather one that portrays a variety of individuals negotiating time and location in order to survive. The world of *Baccano!* is violent, and not just because of its predominantly alternative, American Prohibition-era setting. There is excitement, shock and humour throughout. The number of interweaving tales affecting the characters in multiple ways, or at different times, within their intensely complicated lives makes a lack of total understanding an integral part of the viewing experience. But somehow it all comes together in the end. *Baccano!* claims that stories lack beginnings and ends, and aims to maintain this concept for the viewer as much as the characters.

5 Centimeters Per Second
(Byōsoku Go Senchimētoru [2007]*)*

Directed/written by: Shinkai Makoto
Feature film, 65 mins

5 Centimeters Per Second has received many reviews comparing its animation quality to that of Studio Ghibli, which might seem a little misdirected initially because of that studio's renowned fantasy output, but this film nevertheless has the feel and emphasis on personality, script and drama of such films as *Whispers of the Heart, Only Yesterday* and the television film *Ocean Waves* (1993). *5 Centimeters Per Second* is one of those rare entities, the short feature – a work that is longer than a short film but significantly shorter than standard feature length. But this is to its advantage. This is a succinct film that focuses on the feelings of the characters in a way that is believable and highly detailed without resorting to unnecessary plot exposition.

Split into three sections, *5 Centimeters Per Second* depicts the on/off relationship between Tōno Takaki and Shinohara Akari. They met at junior school and quickly became very close friends, but their relationship is tested when Akari's parents' job means relocating and she has to move to another school in Tochigi. In *Cherry Blossom*, the friends maintain contact despite the distance between them. Takaki learns that he is to move to Kagoshima so he resolves to meet Akari in her new hometown and, despite the uncharacteristically poor rail service that evening, they meet, share their first kiss and spend the night together. In *Cosmonaut*, Takaki has settled into his new school and become proficient at archery. Sumida Kanae has fallen in love with him but does not know if she should reveal her feelings. They have a friendship, but he always seems to be distracted, apparently emailing someone from his phone. Finally, in *5 Centimeters Per Second*, we learn that Akari is engaged to be married. Takaki is now working in Tokyo but finding his job unfulfilling and still yearning for his first love. At a railway crossing Takaki catches a glimpse of someone familiar from the other side of the tracks. By the time the train has passed, she is gone.

The film's subtitle is 'a chain of short stories about distance' and takes an unconventional approach to its narrative, exploring specific episodes in the main characters' lives. There's a connection to the Japanese aesthetic of wabi-sabi, a difficult term to define, but it is concerned with transience, beauty that can be described as imperfect and incomplete. So, for example, wabi-sabi acknowledges that while cherry blossoms (viewing sakura in the springtime is a traditional pastime in Japan) may reach a perfect beauty, it is but fleeting; the budding of the flowers into the peak of their splendour, and also the way that they fade and eventually die, are recognised and appreciated. In *5 Centimeters Per Second*, time, distance, circumstance and communication are all factors that determine whether the relationship can succeed. We have no doubt about Akari and Takaki's burgeoning love for each other – and the sheer bliss of their perfect moment together – but who can be sure what the outcome might be as days turn into months, and months into

years? Lives change, with people following different paths, even if their thoughts return to a past that may have been, but a future that perhaps can never can be.

This film is a beautifully animated drama that not only addresses coming-of-age themes but also the way that, although the world may have shrunk in terms of our ability to communicate across distance, the possibilities that life affords us have changed as well. This is reflected in the sakura (cherry blossoms) which are a recurring metaphor throughout the film. The titular *5 Centimeters Per Second* refers to the speed at which cherry blossoms fall, but it also reflects the way that they fall, the way they may be taken on the breeze and end up somewhere else completely, a gentle allegory for the way that human relationships can drift apart.

Nodame Cantabile (2007)

Directed by: Kasai Kenichi
TV anime, 24 episodes

Next-door neighbours Chiaki Shinichi and Noda Megumi are students at the Momogaoka College of Music. He is ambitious, focused, slightly aloof, and dedicated to pursuing a musical career. She is slovenly, scatty and wants to be a kindergarten teacher when she graduates. But they do have one thing in common: both are incredibly talented musicians. Chiaki plays piano and violin but harbours a secret desire to be a conductor. Noda is a pianist who is undoubtedly capable, but her individualism, her desire to play by ear rather than follow the score, and her lack of focus infuriates her teachers. The pair form an unlikely friendship which might, just might, lead to romance.

Based on the manga by Ninomiya Tomoko, this is a fine example of josei, aimed at a predominantly female market. *Nodame Cantabile* combines a learning-environment setting with a story that has strong character development, incorporating themes of culture and class, and wraps it all up with a gorgeous classical soundtrack.

The contrasting personalities of our two heroes are what make the drama so engaging. Chiaki may be extraordinarily talented, the king of the college, but he has his own issues and paranoias to deal with, particularly a fear of flying, which restricts his career options. He can, effectively, only study and work in Japan. Noda lacks confidence and self-esteem, despite the fact that her playing is very good, if a little unusual in execution. And she could really do with tidying her apartment once in a while. And somehow, despite each occasionally finding the other exasperating, their friendship is solid.

A combination of drama, romance, class, culture, comedy and, most of all, classical music, *Nodame Cantabile* was truly multimedia; the series has also generated live-action TV series plus feature-length, live-action sequels, concerts, video games, CDs and even a café inspired by the series. The anime has two sequels: *Paris Hen* (2008) and *Nodame Cantabile: Finale* (2010).

Shigurui (2007)

Directed by: Hiroshi Hamasaki
TV anime, 7 episodes

In tough and violent times, Fujiki Gennosuke and Irako Seigen are warriors who will face each other in Lord Tokugawa Tadanaga's competition that sees swordfighters engage in bloody battle using real weapons. The combatants are rivals who have developed their skills at Iwamoto Kogan's dōjō (school), each seeking to learn the secrets of their master's techniques, becoming his successor and winning his daughter Mie in the process.

Set in the Edo period, *Shigurui* is a story that is revealed through a series of flashbacks that show how Gennosuke and Seigen came to participate in the contest. The anime begins with the conclusion to the tale but this non-linear construction allows the individual relationships between the pair and the political structure of the society to be depicted in great detail, most notably the reasons for their debilitating injuries, for Gennosuke has one arm and Irako is

blind. Their stories are recalled in concurrent episodes that disclose both their histories and will ultimately determine their fates.

Based upon the manga by Yamaguchi Takayuki, *Shigurui*, which translates as 'Death Frenzy', is a chanbara (swordplay) anime that takes its time telling its tale, but this allows for more fully defined characterisation of the central cast. With fine design and individual character animation, the savagery of the time is depicted with all its atrocities, from the graphic battles that provide the basis for the story to the sexual violence perpetrated towards Mie and the apparently indifferent attitude of her father – who spends much of the running time comatose, aside from sporadic outbursts of awesome swordplay. These levels of graphic violence and sexual revelations are not unheard of in anime but are less common in television-produced works. Madhouse studio produced the series for pay TV firm WOWOW, which allows – at certain times – more controversial material than would be considered generally acceptable for broadcast on mainstream television.

Detroit Metal City (2008)

Directed by: Nagahama Hiroshi
OVA, 12 episodes

Music is not only a personal passion for country boy Sōichi but something that he wants to pursue as a career. Despite his love for composing folksy acoustic pop songs, something his friend and potential girlfriend Yuri also appreciates, Sōichi has actually found his musical vocation as lead guitarist and central ego, Kurauzā, for the band Detroit Metal City, who have already built up a large following. Now, Detroit Metal City don't abide by folksy acoustic pop principles but hard metal rock extremities that endorse sexual violence, abusive violence, anti-establishment violence, satanic violence, well, any forms of violence really, to hordes of adoring fans. Their record manager encourages their escalating aberrations, as well as their fetishistically attired Capitalist Pig man, who

happens to be a masochist and enjoys the onstage abuse. As Sōichi becomes increasingly concerned about his role as a musician in an inappropriate genre, while also trying to hide this publicity-enhanced career persona from Yuri and maintain his folksy acoustic pop ambitions, he also finds that his alter-ego of Kurauzā is becoming increasingly difficult to control.

The OVA releases of *Detroit Metal City* are contained in very short episodes that each have a basic plot but no clear story arc and, frankly, who needs one? This series comprises short skits, which aim to amuse and offend in equal measure. A lot of the subject matter is thoroughly distasteful, but it is clear from the outset that *Detroit Metal City*'s tongue is placed very firmly in its cheek (and probably someone else's too!). The characters are all sketched with a disregard for the quality of the animation and this suits the series' anarchic style. *Detroit Metal City* entertains on a plethora of levels, some of which are deeply inappropriate, but in many ways that is the entire point. It isn't meant to be philosophical or provide a moral judgement on media/rock/youth culture any more than it is trying to say that folk pop is great. There is a sweet attempt at romance – which Kurauzā, DMC or their fans foil at every opportunity – but the series' main purpose is to turn the crude comedy up to eleven. Confrontational, irresponsible and occasionally reprehensible, *DMC* is very, very funny, but don't watch if you are easily offended.

Junjō Romantica (2007)

Directed by: Kon Chiaki
TV anime, 24 episodes

Junjō Romantica was the first yaoi manga to reach the *New York Times* manga bestseller list. It also proved to be popular both in Japan and overseas when the anime, produced by Studio Deen, was released on DVD. Yaoi is one of the terms used to describe Boys' Love (BL) anime, that is, where relationships between men are a key part of the story. Its market is primarily for women (bara

defines the material targeted at gay men) and many yaoi writers are female. The yaoi format generally uses a standard characterisation to define the relationship – the seme is the dominant partner and the uke is the passive partner. Both partners are, of course, gorgeous to look at. Yaoi can contain explicit scenes but does not necessarily have to, and many yaoi anime focus on the romance of the story. *Junjō Romantica*, which translates as 'pure romance', was based on the manga by Nakamura Shungiku.

The series revolves around the development of three relationships involving a main couple (the Romantica pair) and two other couplings – the Egoiste and Terrorist pairings. The primary story is that of Takahashi Misaki who is determined to get into university. He is tutored by his brother's best friend, the famous novelist Usami Akihiko (nicknamed Usagi, which means 'rabbit') and quickly discovers that Usami is very much in love with his older brother. Takahashi Takahiro, however, is completely oblivious. When Takahiro gets engaged to be married, Usami calmly gives up any hope of them forming a relationship, but Misaki cannot understand why his friend doesn't fight for his brother. Usami is touched by Misaki's concern and, when the young student moves in with him so that he can study at the local university, Usami realises that he is, in fact, in love with the younger brother.

Alongside the romance, the series has loads of humour. Usami is an interesting character – from a well-to-do household, he spent his early years in England and didn't have much of a family life. As a result he has filled his apartment with toys and teddy bears, in an attempt to recreate the childhood he never had. He is not only a famous novelist, he also writes BL novels using a pseudonym and Misaki is usually horrified, when he reads them, to discover that Usami has committed his fantasies about their love life to print. Usami's editor is a complete fangirl and just adores reading these naughty novels, much to Misaki's chagrin. The series becomes increasingly romantic as the relationships between the pairings develop and any sex between the couples is mainly implied. *Junjo Romantica* is both funny and sweet.

The Sky Crawlers (2008)

Directed by: Oshii Mamoru
Feature film, 121 mins

The world is at war, a war where combat is broadcast daily by an enthusiastic media that reports on the frightful skirmishes and dogfights that take place in the skies above. Kannami Yūichi is a combat pilot whose abilities and technical prowess are indisputable, and he joins Rostock Corporation to carry out the missions required of him. His skills are supreme despite his apparent youth and he joins a team of similarly young combatants, including Commanding Officer Kusanagi. But why are there so many young pilots in the team? And why do they not seem to age? What exactly are the kildren?

Hanging out in bars with comrades, drinking beer, chain smoking and engaging in escapades with the opposite sex between military encounters would seem to be an integral part of the flying-trooper subgenre, but *The Sky Crawlers* presents an alternative world with a premise that is significantly more complex. War is run by corporations as entertainment because the world simply cannot function without conflict. And if the world needs combat it also needs combatants. And this is where the kildren (an accidental derivative of the corporation's genetic research experiments) come in; adolescents who are sent to embark on these potentially lethal missions unaware of their genetic status. The film asks deep ethical questions about the kildren and their role in society. They are adolescents except they are not. They have a longevity that makes them completely resistant to any ageing process, hence they can only die if they are killed. They can be pilots, drink alcohol, smoke and become parents. They are not coerced into fighting but don't (initially) think to question their lives. Are they cursed, blessed or just plain different?

Technically the anime uses a careful combination of CGI and cel-based techniques to stunning effect. The flight sequences are created using CGI, to the extent that they look photorealistic, contrasting

with the flat, cel-animated characterisation, to link the world and its protagonists in a manner that borders on anime art-realism.

Despite being punctuated by scenes of intense aerial action, the rest of the film moves at a sedate pace. Perhaps it is the characterisation that most stands out in *The Sky Crawlers*. Oshii perfectly captures the impassivity of a young man whose only purpose is to kill or be killed. He has figured out how to live only for the present. The only time we ever see Kannami smile is when he puts on a forced grin, when being interviewed by the visiting sponsors. Despite the media lauding him as a hero, he doesn't behave like one. He doesn't know how. A moving film that asks more questions than it answers, *The Sky Crawlers* is restrained and melancholy but a thoroughly rewarding experience.

Fullmetal Alchemist: Brotherhood (2009–10)

Directed by: Irie Yasuhiro
TV anime, 64 episodes

Produced by Bones, the *Fullmetal Alchemist* anime series concluded its original run in 2004 before the manga upon which it was based had finished and, with mangaka Arakawa Hiromu's permission, took the story in its own direction. *Fullmetal Alchemist: Brotherhood* returns to the source material. At its heart the story revolves around two central characters, one virtually mecha in appearance but all too human, recalling such classic anime as *Appleseed*, although here the brothers' relationship, together with the story of their past lives, caught up in their world's political and religious nightmare, helps enhance the elements of action, drama and fantastical revelation to create a series with surprising emotional strength.

Edward Elric, a smart-spoken, bright, scientific young man with strong combat skills, is constant companion to his brother Alphonse, who is similarly talented but physically restricted to surviving within a suit of armour following a near-fatal accident. Both are highly skilled in the art of alchemy; indeed, Edward is one of the

youngest State Alchemists, known as the Fullmetal Alchemist, invited to join the military in order to help fulfil his goal of seeking the Philosopher's Stone, which he believes will provide the means of returning Alphonse's body to the corporeal world. You see, the accident was caused by the young brothers' attempts at human transmutation, in order to resurrect their beloved mother, who had recently died. But they didn't realise that, with alchemy, there has to be equal exchange. And so they created a monster; Alphonse's body disappeared and Edward lost his leg. The elder sibling then sacrificed his arm in order to bind his brother's soul to the suit of armour, and replaced his missing limbs with mechanical automail. The pair live in a violent world, where politics and terrorism are rife, and they have enemies in the form of homunculi, created human beings, named for the seven deadly sins.

What makes *Fullmetal Alchemist* work so well is its absorbing plot, which is intelligent and complex, not simply following the brothers' story, but taking in wider political, social and religious issues in a world of magic and militia. The cast of wonderful supporting characters – from the brothers' childhood friend and automail expert, Winry, to their utterly terrifying sensei (teacher), who storms around in her bathroom slippers – just adds to the depth of the story. The magic lies with the way that you care about even the most minor of characters, which is why their demise or change of allegiance can be so shocking.

The Brotherhood of the title is crucial to understanding the compassion in this anime, which makes for a story that can be incredibly moving at times, particularly when it recalls the past and the way Edward has become the brother to Alphonse that he has. A deeply involving series with humour, action, adventure, conflict, scares and genuine pathos, *Fullmetal Alchemist* is a hugely rewarding experience – you'll be rolling on the floor with laughter one moment, then reaching for a box of tissues the next – which appeals to a far wider audience than its shōnen demographic suggests.

Summer Wars (2009)

Directed by: Hosoda Mamoru
Feature film, 114 mins

Welcome to the world of Oz. It's very different to the one that Dorothy visited – a virtual reality accessed through computers, phones and TVs. It's a world where you can meet real people from other nations or areas of space that are either very familiar or completely new. It's addictive. Natsuki, like many of her schoolmates, is one of the countless users of Oz, but she has real-world commitments too, because she has to attend a family reunion in the country to celebrate her grandma's birthday. Her good friend Kenji agrees to accompany her, and also to pretend that he is engaged to Natsuki to make her grandmother happy. Their worlds become linked in the strangest of ways as family issues in the real world become increasingly entangled with Oz. The virtual world is becoming far more dangerous as evil, violent characters begin to seek cruel dominance. Can the pair do anything to stop the burgeoning madness and restore Oz to a more satisfactory environment? And maybe fall in love as well?

Summer Wars combines a sweet drama about a budding relationship with a science-fiction scenario that also takes in politics, multiculturalism and family dynamics amongst its many themes. It also flips us between virtual and real worlds where one increasingly exerts an influence on the other, although Hosoda's film provides the audience with a distinction between normality and the 'other world' even if the characters don't always realise this. Also interesting is the way that the real world is defined in terms of the differences between the consumer-focused cities and the traditional rural setting of granny's home – there is a sense that virtual worlds not only remove people from the actual one but also reflect the way that modern society has replaced older traditions and etiquette. *Summer Wars* has something for everyone – a tale of genuine friendship between its impressive set pieces. It followed

Hosoda's *The Girl Who Leapt Through Time* (2006), a delightful anime which established the director as a talent to watch out for.

FURTHER READING

Camp, Brian & Julie Davies, *Anime Classics Zettai!*, Stone Bridge Press, Berkeley, 2007

Clements, Jonathan & Helen McCarthy, *The Anime Encyclopedia: Japanese Animation Since 1917*, Stone Bridge Press, Berkeley, 2006

Galbraith, Patrick W, *The Otaku Encyclopedia*, Kodansha International, Japan, 2009

McCarthy, Helen, *The Art of Osamu Tezuka: God of Manga*, ILEX, Lewes, 2009

Odell, Colin and Michelle Le Blanc, *Studio Ghibli*, Kamera Books, Harpenden, 2009

Richie, Donald, *A Hundred Years of Japanese Film*, Kodansha International, London, 2001

Schilling, Mark, *The Encyclopedia of Japanese Pop Culture*, Weatherhill Inc, Trumbull, 1997

REFERENCES

1 Guardian.co.uk, 10 April 2009
2 The Japan Foundation Travelling Exhibition: JAPAN: Kingdom of Characters, Japan Foundation
3 Ibid
4 Donald Richie, *A Hundred Years of Japanese Film*, Kodansha International, London, 2001, p 26
5 The Japan Foundation Travelling Exhibition: JAPAN: Kingdom of Characters
6 *The Art of Osamu Tezuka: Secrets of Creation*, DVD, Media International Corp
7 Ibid
8 Jeff Berkwits, Scifi.com Issue 248, 'Animation legend Rintaro reinvents the city to build a better Metropolis'
9 http://www.macrossworld.com/4114/interview-with-shinichiro-watanabe-on-10-november-2012-during-anime-festival-asiaafa-2012/

INDEX

kamerabooks.com

ISBN: 978-1-84243-937-1 **£16.99**
ePub: 978-1-84243-938-8 **£13.97**

The Films of Pixar Animation Studio

JAMES CLARKE

Almost 30 years since its inception, now a major icon of cinema and pop-culture, Pixar Animation Studios has played a vital part in reminding audiences of animation's capacity as a significant artform. Hugely popular with both children and adults, and recognised as a real force in the imaginative lives of its audience, Pixar's movies have also attained great critical acclaim.

This book considers the studio's entire output from their short films and earliest experimental pieces to successes such as *Toy Story*, *Monsters Inc*, *Finding Nemo*, *Cars*, *Ratatouille*, *Wall-E* and *Up*, and includes interviews with key creatives.

kamerabooks.com/pixar

ISBN: 978-1-84243-954-8 £16.99

The Making
Hitchcock's

TONY LEE MORAL

In his most innovative and techn
Alfred Hitchcock followed the succ
avant-garde horror-thriller, which has spawned many imitators. To
mark the film's 50th anniversary *The Making of Hitchcock's The
Birds* is the first book-length treatment on the production of this
modernist masterpiece, written with the cooperation of Universal
and the Hitchcock Estate.

Featuring new interviews with stars Rod Taylor, Tippi Hedren and
Veronica Cartwright, as well as sketches and storyboards from
Hitchcock's A-List technical team, the book charts every aspect of
the film's production.